BRISTOL
BRABAZON

BRISTOL BRABAZON

GRAHAM M. SIMONS

The History Press

Cover illustrations: front: the prototype Bristol Type 167. (Mirrorpix); *back*: two airframes are unceremoniously destroyed at Filton by R.J. Colney, the aircraft scrappers. (Simon Peters collection)

First published 2012
Reprinted 2019

The History Press
97 St George's Place
Cheltenham, Gloucestershire, GL50 3QB
www.thehistorypress.co.uk

British Library Cataloguing in Publication Data.
A catalogue record for this book is available from the British Library.

ISBN 978 0 7524 6733 7

Typesetting and origination by The History Press
Printed in Great Britain by TJ International Ltd, Padstow, Cornwall

CONTENTS

INTRODUCTION

When anyone looks back on the Brabazon airliner with the benefit of hindsight, it is very easy to see the design as a white elephant – a complete failure. Indeed, it is easy to ask oneself, 'what on earth were those involved with it thinking about?'

This is exactly the attitude that many post-event commentators have adopted when recording the history of this particular machine, but is it a valid one? Those making the decisions at the time did not have the luxury of hindsight; all the indications at the time were that the future of civil air transport lay with large, luxurious landplanes and flying boats and so they considered, planned and built accordingly.

Planning started during a time of conflict with that most typical of British institutions – the committee. It was set up with a number of aims in mind, but namely to study the perceived airline requirements when the war was won so as to provide an integrated design plan across a number of aircraft types and sizes, a plan that would put the United Kingdom in a position to steal a march on the Americans. As we shall see, the core thinking of the day behind the overall concept was right. This resulted in some of the suggestions being successes, others not so.

The aircraft design described here – termed the Brabazon Type I, the Bristol Type 167 or simply the Bristol Brabazon – was just one of these designs. It was larger than anything else ever attempted in the UK before and showed that the British were determined to embrace cutting-edge technology to push the envelope, so as to maintain its position in the aviation world. Unfortunately, that world was on the cusp of a change – a change that many did not realise was about to hit, nor with such great impact. The jets were coming, led by the de Havilland Aircraft Company with their incredible Comet airliner, but that is another story!

I

IN THE BEGINNING

The obvious starting point to the Brabazon story is July 1942, when Colonel John Jestyn Llewellin, 1st Baron Llewellin, GBC, PC, MC, TD and Minister of Aircraft Production, asked his predecessor, Lord Brabazon of Tara, to form a committee to recommend what types of civil aircraft should be built in Britain after the Second World War. The use of such long-term planning was most un-British and almost unheard of, especially at the darkest hour of the war when there were other things to think about.

The outbreak of the Second World War had more or less put a halt to all thoughts on transport aircraft design. It was generally understood that the United States of America and the United Kingdom would split responsibility for building multi-engine aircraft types: the US would concentrate on transport aircraft while the UK would concentrate on heavy bombers. It was soon recognised that as a result of that decision the UK was to be left at the close of the war with little experience in the design, manufacture and final assembly of large transport aircraft, and with no infrastructure or trained personnel. Yet over in the US a massive infrastructure had been created that would allow them to produce civilian aircraft based upon military transport designs and, crucially, it had been suggested that these would have to be purchased by the UK, Empire and Commonwealth to meet their own post-war civilian transport aviation needs.

The UK did not completely abandon all thoughts of transport aircraft development, however. In 1941 a committee was formed on civil aviation to consider transport variants of military aircraft, and among the aircraft reviewed were the Short Shetland and Stirling.

Around the same time, Sir Ralph Sorley of the Air Ministry and Sir Roy Fedden, formerly the chief engineer and designer at the Bristol Aeroplane Company Ltd, visited the US where they were shown some of the work being carried out on civil designs such as the Douglas DC-4 and Lockheed

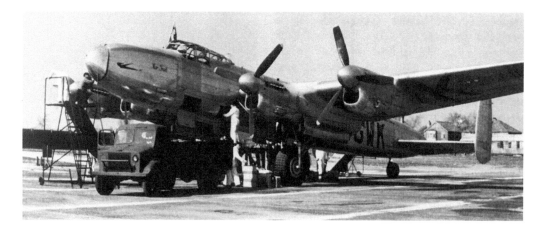

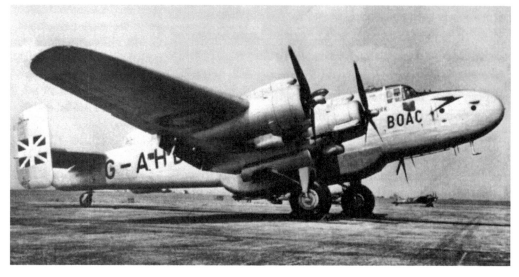

Constellation airliners. The Americans were building their next generation of civil transport aircraft, as was their way, under the guise of transport machines for the military, but it was clear that when the war was won they could be easily transferred to civilian use and they would be big.

Boeing had their double-deck Model 377 Stratocruiser (a derivative via the C-97 Stratofreighter of the B-29 Superfortress bomber). The Stratocruiser could carry up to 100 passengers on the main deck and a further fourteen in the lower lounge, but more usually carried around sixty in luxury. The Douglas Aircraft Corporation were not only building their C-54/DC-4 but were also expanding that particular family group into the DC-6 and DC-7, along with the even larger C-74 Globemaster 1 that had the capacity to carry 125 troops and their equipment. Lockheed Aircraft, meanwhile, were busy with their Constellation family of airliners and were also engaged in creating their own double-decked aircraft, the Constitution, which was capable of uplifting 168 passengers. Convair were proposing a transport version of their B-36 Peacemaker bomber, the C-99, which had a capacity for 400 troops.

Reporting on their return, the British government announced its intention to investigate the development of future civil transport designs. Following this, the Ministry of Aircraft Production and the Secretary of State for Air appointed a more challenging inter-departmental committee. Its remit was to '... advise on the design and production of transport aircraft'. The committee's objective was to recommend a number of designs for development; designs which would not be in direct competition with those aircraft from the US – they were going to be up against some pretty stiff opposition! These new aircraft would be required to demonstrate a significant advance in design, 'jumping a generation' and therefore stealing a march on the US products.

The committee set up by Colonel Llewellin, the Minister of Aircraft Production, was originally called the Transport Aircraft Committee and began work on 23 December 1942. Its remit was to prepare an 'outline specification for several aircraft types needed for post-war air transport' and also to consider which military aircraft could best be converted into transport aircraft. This, it was felt, was essential in order to maintain the industry in the short term, both in design and production, when the war finished, thus ensuring that American transports were not bought, allied with the expected foreign currency problems that would be caused by any American purchase.

John Theodore Cuthbert Moore-Brabazon, 1st Baron Brabazon of Tara, GBE, MC and PC, was born in London to Lieutenant Colonel John Arthur Henry Moore-Brabazon (1828–1908) and his wife, Emma Sophia. He was educated at Harrow School before reading engineering at Trinity College, Cambridge, but did not graduate. He spent university holidays working for Charles Rolls as an unpaid mechanic, then became an apprentice at Darracq in Paris after

John Theodore Cuthbert Moore-Brabazon, 1st Baron Brabazon of Tara GBE, MC, PC (8 February 1884–17 May 1964). 'Brab' was such a pioneer that he was the first to prove that pigs could fly, as shown in this 1909 picture signed in 1939 to Sir Kingsley Wood, a Conservative politician. (Brian Cocks Collection)

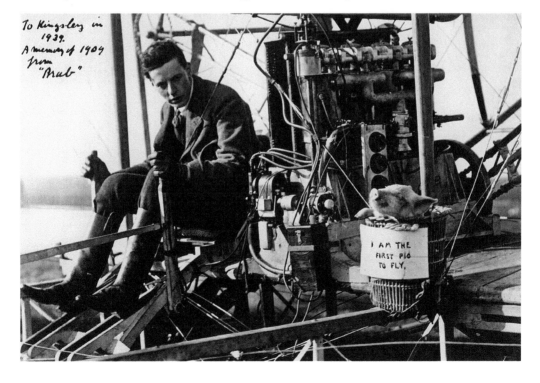

leaving Cambridge. In 1907 he won the Circuit des Ardennes at the Circuit de Bastogne. This was the first major auto-race to run on a closed course instead of from one city to another and was in many respects the precursor to today's Grand Prix.

With the outbreak of war, Moore-Brabazon returned to flying, joining the Royal Flying Corps. He served on the Western Front where he played a key role in the development of aerial photography and reconnaissance. In March 1915 he was promoted to captain and appointed as an equipment officer. On 1 April 1918, when the Royal Flying Corps merged with the Royal Naval Air Service to form the Royal Air Force, Moore-Brabazon was appointed as a staff officer (first class) and made a temporary lieutenant colonel.

Much has been made of the fact the Brabazon was too large and too luxurious, but many forget that other aircraft fell into the same category. In the USA, American aircraft manufacturers were building large, luxurious piston-engined airliners. British Overseas Airways Corporation (BOAC) eventually purchased a number of Boeing Model 377 Stratoliners. G-AKGH Caledonia *in the new BOAC livery with the blue cheat line and 'Speedbird' logo on the fin. (Left) BOAC operated the Monarch Class on their Stratocruisers and here one of their passengers receives 'breakfast in bed'. (Both BOAC)*

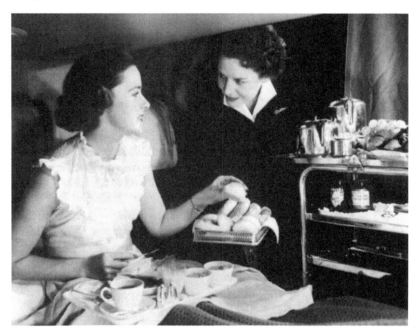

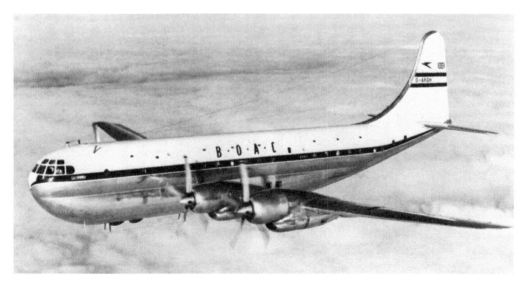

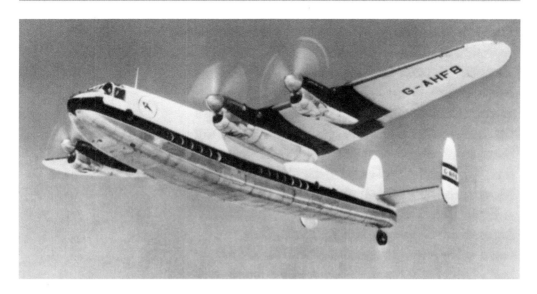

Moore-Brabazon finished the war with the rank of lieutenant colonel, was awarded the Military Cross and became a commander of the Légion d'honneur. He later became a Conservative Member of Parliament for Chatham (1918–29) and Wallasey (1931–42), and served as a junior minister in the 1920s. In Winston Churchill's wartime government he was appointed Minister of Transport in October 1940 and joined the Privy Council, becoming Minister of Aircraft Production in May 1941. As the Minister of Transport he proposed the use of airgraphs to reduce the weight and bulk of mails travelling between troops fighting in the Middle East and their families in the UK. He was forced to resign in 1942 for expressing the hope that Germany and the Soviet Union, then engaged in the Battle of Stalingrad, would destroy each other. Since the Soviet Union was fighting the war on the same side as Britain, the hope that it should be destroyed – although a common view in the Conservative Party – was regarded as being completely unacceptable to the overall war effort. Moore-Brabazon was thus elevated to the House of Lords as Baron Brabazon of Tara, of Sandwich in the county of Kent, in April 1942.

The Avro York began life as a VIP transport in 1943 and large-scale production followed for the RAF, BOAC, BSAA and others. (BOAC)

The Brabazon Committee

The study known as the Brabazon Committee, after its creator, was an attempt at defining in broad overview the future needs of the British civilian airliner market. It would look at the impact of projected advances in aviation technology and forecast the global needs of the post-war British Empire (in South Asia, Africa, the Near and Far East and in the British Commonwealth of Australia, Canada and New Zealand) in the area of air transport, passenger, mail and cargo.

The members of the committee were to be taken from the Air Ministry, Ministry of Aircraft Production and Ministry of Production. These were Lieutenant Colonel Sir Francis Shelmerdine, an ex-director of civil aviation;

Norbert Edward Rowe, the director of technical development at the Ministry of Aircraft Production; Sir Henry Self; Sir William Hildred, the director general of civil aviation; Sir Kelvin Spencer from the Ministry of Aircraft Production; and John Hadlow Riddoch, from the Air Ministry as secretary.

As Lord Brabazon explained in 1949:

> Towards the end of the war, the Secretary of State for Air and the Minister of Aircraft Production set up a committee to voice users' requirements as to the future types of civil aircraft required. It was a very talented committee, and I was privileged to be its chairman. It held, I think, something like sixty meetings and made recommendations as to the necessity of building five new types.
>
> After so many years have passed it is interesting to see what has been evolved from the recommendations of the committee. Starting at the wrong end, so to speak, the Brabazon recommendation No. 5 has produced the Dove, which was 5A, and the Marathon, which was 5B. Brabazon recommendation No. 4 was for a full-jet transport machine, which has just been flown and is, of course, the wonderful Comet. Brabazon 3 was never ordered but was, in fact, a recommendation to produce new four-engined civil machines of about 100,000 lb weight, to replace the bomber types. It has, however, recently been ordered by the Ministry, but very late. Brabazon 2 produced the Ambassador. In Brabazon 1 we desired a machine which would fly non-stop New York to London – that was its job, and nothing else. Technical reasons forced this machine to be ultra-big to take its useful load and fuel and it was, indeed, not one step forward in size but about three steps forward.
>
> All the time we had in view the possibility of gas-turbine propulsion instead of piston engines. Much research work has been done on the Bristol machine which will be common to all big aircraft. A new gas turbine is being evolved, a new airfield has been put down and vast, much needed hangars constructed, with the result that the bill, all put down to the building of this machine, has swollen to a vast size. The Bristol Company has tackled the project with painstaking care, and it is the hope of everyone in this country that this pioneer experiment in great aircraft will be the success it so richly deserves.

The study both recognised and accepted that the British Empire and Commonwealth, as both a political and economic entity, would have a vital need for aviation systems – but principally aircraft – to facilitate its continued existence and self-reliance in the post-war world. For military and commercial reasons the empire simply could not continue to exist if it did not understand the needs and develop the industrial infrastructure to provide the aviation systems and sub-systems necessary to supply and maintain a global air-transport service.

The committee reported to the Cabinet on 9 February 1943 and proposed four types of military aircraft that could be converted to commercial transports for the interim. These were the Short Sunderland, a variant of the Handley Page Halifax with a new larger fuselage (which became the Hermes in civil form), the Lancaster-derived Avro York and the Short Shetland. The report

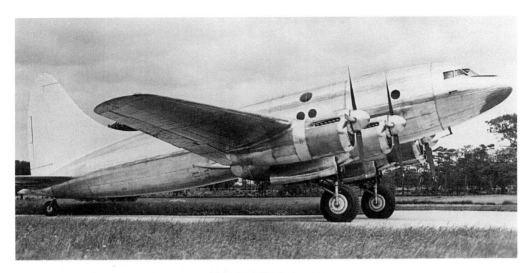

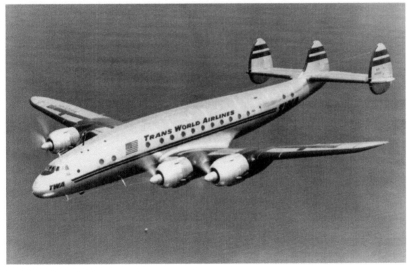

The twelve-seater Avro Type 688 Tudor I first flew in June 1945. Fourteen were ordered by the Ministry of Supply for BOAC, but the type became a victim of protracted modifications and re-design. (BOAC)

The Lockheed Aircraft Corporation of the USA made a giant leap forward with its elegant triple-finned Model 749A Constellation, as seen here. (Trans World Airlines, TWA)

also continued with plans for five completely new commercial landplanes that were numbered from one to five and would give valuable production work after the war. These were:

Type 1 – A pressurised long-range airliner capable of flying non-stop from London to New York. It was to be powered by six or eight engines with a cruising speed of 275mph. It was estimated that this project would take more than five years to reach production.

Type 2 – An unpressurised DC-3 replacement able to carry twenty passengers on empire and European feeder services at more than 200mph.

Type 3 – A four-engine, empire route airliner to replace the York.

Type 4 – A jet-propelled mail plane cruising at more than 400mph and capable of crossing the North Atlantic.

Type 5 – A small feeder-liner to carry up to twelve passengers for colonial and domestic UK routes.

BOAC were to operate a number of Canadair North Stars under the type name of 'Argonaut' – a Canadian development of the Douglas C-54/DC-4. Instead of radial piston engines found on the Douglas design, the Argonauts were powered by Rolls-Royce Merlins, which saved on dollars due to the currency crisis! (BOAC)

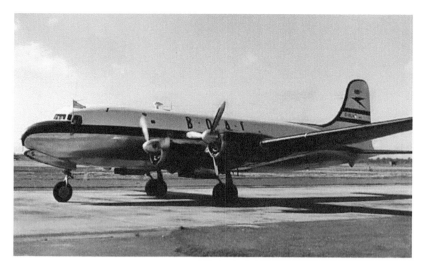

The Douglas C-74 Globemaster was a heavy-lift cargo aircraft built by Douglas in Long Beach, California. It was developed after the Japanese attack on Pearl Harbor. The distances across the Atlantic and Pacific Oceans to the combat areas indicated a need for a transoceanic heavy-lift transport aircraft. Douglas responded in 1942 with a giant four-engined design. (Douglas)

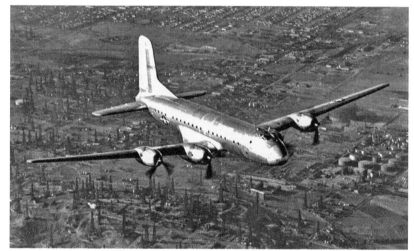

The report emphasised the need for work to start on at least four of the five types as soon as possible, otherwise the types as finally produced would already be obsolete. It just so happens that the one that the world really wanted, the Type 3 (which with four Bristol Centaurus engines could have been superior to Lockheed Aircraft's Super Constellation, Douglas Aircraft Corporation's DC-6B or the Boeing Stratocruiser), was the only one that was never built. From the very beginning the type that attracted the top priority and the intense attention of the government was the Brabazon Type I.

The Viewpoint of the Day

The Brabazon Type I called for the first aircraft in the world to carry a useful load from London to New York. With allowances this meant a still-air range of 5,000 miles, necessitating an aircraft of enormous size and weight. Commentators have subsequently claimed that it was just the kind of thing

governments used to like, but we cannot be sure that they are only making that statement with the benefit of hindsight.

One should remember that at the outbreak of war in 1939 the luxurious but very slow Handley Page HP.42 was less than ten years old and still in service, whilst the Armstrong-Whitworth Ensigns were operating to India, Africa and in many stages all the way to Australia. On water, the luxury of the Short Brothers' C and G Class flying boats was very much the norm, and all flights were being made over short-stage lengths and in high luxury. Indeed, most services never operated at night! If the services were not of that nature, then they were being flown in small, eight to twenty-seaters such as the DH.86 Express and DH.89 Dragon Rapide. Certainly, the Brabazon Type 5 was called 'a Rapide replacement'.

It was not many years previously that the travelling public were enjoying the luxury of the Ensign's promenade deck (left) to look down on the scene below as the aircraft went to Africa, India and Australia. Otherwise, they were travelling in ponderous majesty aboard Imperial Airways' Silver Wing service to Paris and other European capitals aboard HP.42s.

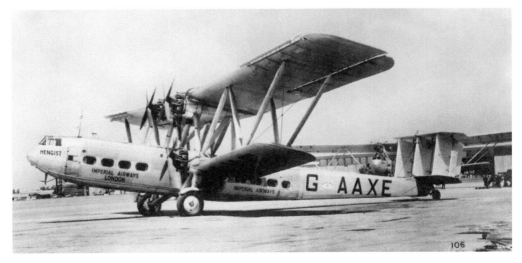

This was very much the mindset of many of those involved in the Brabazon Committee, based on their experiences of operating Imperial and British Airways. It's understandable that they were thinking along those lines; larger, faster and long range, certainly, but ultimately just following what had been established.

In 1943 a second Brabazon Committee was formed to assist the detailed implementation of the first committee's recommendations, which had been accepted fully by the government. This committee was to 'consider the types recommended in relation to traffic needs and economics and to prepare a list of requirements for each type in sufficient detail to provide a working basis for design and development and to recommend accordingly'. Among the members of this new committee were Captain Geoffrey de Havilland and Alan Colin Campbell Orde, who represented the aircraft manufacturing and airline industries, respectively.

The first report was issued in August 1943 and mostly concerned the importance of the Type 1, with its non-stop, all-year North Atlantic service. A second interim report, published in November, proposed that the Type 3 specification be split into two, with the original design becoming the Type 3A, while a new medium/long-range empire/European aircraft able to carry between forty and sixty passengers became the Type 3B. The Type 5 specification was

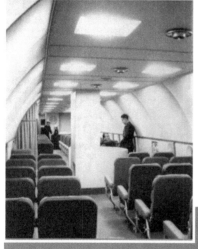

also split, with the Type 5A being a new fourteen-seater and the Type 5B taking on the old Type 5 specification for an eight-seater. The report also called for the conversion of the Lancaster IV for commercial use – requiring a pressurised fuselage and improved win. The aircraft, as proposed by the Air Ministry, became the Avro Tudor.

A third interim report in July 1944 saw a fundamental change, as the Type 4 specification evolved from a mail plane into a passenger-carrying jetliner for empire and European routes. Meanwhile, the Type 5A was now recommended with four engines and the 3B was proposed for long-haul European, South African and empire services.

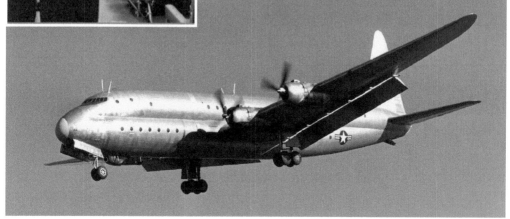

The forth interim report was published in November 1944, by which time the Type 1 had become known as the Bristol Type 167, with proposals for a stretched variant for short-haul services. Now that the Bristol Type 167 had further potential in addition to one-stop and non-stop transatlantic services, and with the availability of the Tudor, the need for the Type 3A was not as urgent. A new Type 3 specification was thus issued, replacing Types 3A and 3B with two pressurised twenty-five-passenger aircraft for medium/long-haul empire services.

By the time the fifth interim report surfaced in November 1945, the committee had already recommended the development of a Type 2B turboprop medium-haul airliner (the original Type 2 becoming the 2A) for which two separately designed prototypes were to be ordered.

Priority was given to the Brabazon Type I. It is interesting to see how people planned and thought in those days: the government stressed that 'financial considerations must necessarily be secondary' and BOAC (British Overseas Airways Corporation) was merely requested to 'associate itself closely with the layout of the aircraft and its equipment'. Nobody, it seems, asked if they actually wanted or needed the Brabazon Type I. In a more sensible society, where new airliners emerged only to meet the need of a customer, would they have written the same specification?

In the original deliberations of the Brabazon Committee the justification for the project was two-fold. Firstly, national prestige and pride had yet to become dirty words. Secondly, elimination of the need to refuel in Newfoundland – if not in Iceland as well – was expected to improve service reliability significantly. This problem has largely been forgotten about today in the new era of long-range, extremely reliable jet airliners, but in the 1940s it was very real.

Sir Miles Thomas, DFC, MI.Mech.E., MSAE and chairman of BOAC, explained some of the requirements in 1949:

Sir (William) Miles Webster Thomas, Baron Thomas, Lord Thomas of Remenham, known as Sir Miles Thomas or Lord Thomas, DFC (2 March 1897–8 February 1980).

Following the decision in 1943 by MAP [Ministry of Aircraft Production] and the Air Ministry to order prototypes of the Bristol 167, BOAC was asked to associate itself closely with the design and development; this association would include advising MAP and the Bristol Aeroplane Company on the layout of the aircraft and its equipment. Before mentioning the more outstanding examples of the collaboration, it is necessary to refer briefly to the broad approach followed by BOAC in seeking the objectives of safety, performance and earning power.

The original conception of the Brabazon Committee was largely based upon the prestige value of a direct London–New York service coupled with the regularity to be gained by elimination of the uncertainties of refuelling in Newfoundland. This meant a highly specialized design, and the official view was that the Bristol 167 represented the size required to deal with this very large air mileage requirement. The design of the Mark II prototype, now

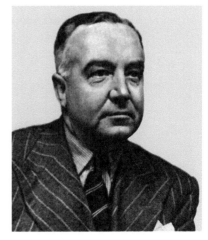

more than half completed, shows the improvements made – they include, in particular, greater operational flexibility; this should be of great value, however it may be decided to operate the aircraft.

With any commercially competitive scheduled air service, high fleet utilization must be a first aim. The larger the unit the more difficult this becomes and correspondingly greater emphasis is placed on both mechanical dependability and operational regularity. The former means designing for consistency of performance and easy maintenance from the outset; the latter means – particularly where flight cancellations due to adverse terminal forecasts would have catastrophic repercussions upon planned aircraft movements and thus on booking office and hangars – all-round reductions of operating limits through better route facilities and operating techniques. It is proposed to refer specifically to some of the development done up to this stage under the first heading as the result of collaboration between BOAC and the firm:-

(1) Safety:-
 (i) Best location of emergency exits; details and location of life-saving equipment, etc.
 (ii) Design criteria for airframe and engine anti-icing.
 (iii) Advice on fire precautions.
(2) Increasing 'payability':- The original specification was for a 50–72 passenger aircraft for direct operation between London and New York throughout the year. This target would have seriously restricted the revenue potential of so large an aircraft. Studies by BOAC which, incidentally, meant establishing de novo the best method of operating turbine-powered aircraft, have raised the target to at least 100 passengers by more efficient use of fuselage volume.
(3) Maintenance features:- The wealth of BOAC's experience has been put into the redesign of many items to improve maintenance; this is possibly BOAC's most valuable contribution. Because of size alone there has had to be much specialized design, including handling equipment for ground use.
(4) Increased operational flexibility:- Continuous operational and design investigations with the firm have resulted in:-
 (i) Development of an eight-tyred four-wheel bogey undercarriage to reduce runway bearing loads.
 (ii) Improvements to the cabin air supply, thus increasing passenger capacity, which was previously limited by this feature.
 (iii) Raising the original structural wing bending moment limit to the maximum payload which could be carried, even on short sectors.
(5) General operating advice: In particular:-
 (i) Policy for the electrical systems.
 (ii) Methods of operating reversible-pitch airscrews, since widely adopted.
 (iii) Wheel braking systems.
 (iv) Take-off and landing procedures, thus influencing undercarriage and flap design, and their operation.

The first studies suggested a landplane carrying a minimum of twenty-five passengers in convertible berths and with a gross weight of about 150,000lb. Some experts, however, considered the aircraft ought to be bigger. It was obviously going to need a major effort; the committee decided 'the production batch are unlikely to be available until the end of the 5th year' and the Ministry of Aircraft Production decided to press ahead as fast as possible, provided the work did not interfere with the war effort.

The so-called 100-ton bomber came about as the result of a number of specifications from the Air Staff, who issued 'Specification B.8/41' for a heavy bomber to carry a bomb load of 10,000lb at 300mph over a range of 4,000 miles. Bristol Aeroplane Company was neither invited to tender for this nor was it informed of its existence until 1942, when it was asked to submit a study for a larger bomber of 100,000lb all-up weight, with four Centaurus or six Hercules engines. It was soon evident that to meet the specified range and speed, with an adequate margin of drag for two or three gun turrets, a substantial reduction in overall drag was essential. In-depth analysis of the best existing designs demonstrated that conventional wing-mounted engines accounted for 30 per cent of the total drag, although only 5 per cent was actually needed for engine cooling. If the engines could be completely submerged in the wing, they were thus likely to reduce the total drag by 25 per cent – if the concept was technically feasible.

For this to be possible the wing would have to be at least as thick as the height of the engine, while coupling several engines side by side to a single airscrew unit located well inboard would leave the outer wing free from interference and available for fuel storage. Investigations in September 1942 indicated that still larger aircraft could achieve ranges of between 4,500 and 5,000 miles. German penetration into Russia and Japanese gains in the Pacific emphasised the need for a really long-range bomber, and the company's

It was not just the Americans and the British who were thinking big – in the Soviet Union, the Tupolev design bureau built the massive Tu-114 which had a main cabin that could accommodate between 120 and 220 passengers.

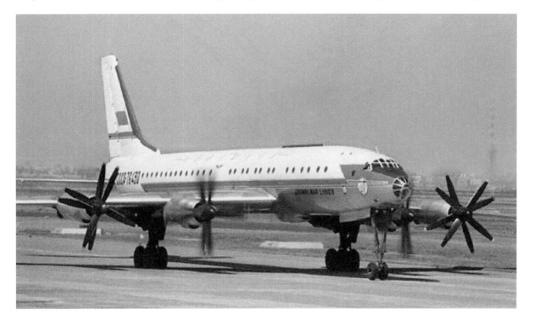

proposal for a large 5,000-mile aircraft met with some interest from the Air Staff. Outlines were studied with six Centaurus, eight Griffons and, eventually, eight Centaurus considered.

The last of these outlines, in November 1942, showed a mid-wing monoplane of 225,000lb all-up weight, 225ft span, 5,000sq ft wing area and 10:1 aspect ratio – the limit imposed by structural considerations. The depth of the inner wing was then just adequate to submerge a Centaurus engine without excessive thickness/chord ratio, but only if the engines were closely pitched in a coupled power-plant arrangement. The final Bristol 100-ton bomber had a very slender fuselage and a butterfly tail, close to the ideal minimum drag shape. Comparable designs, some tailless, were put forward by other firms, but all were rejected by the Air Staff in favour of increased production of Avro Lancasters and it appeared that no further interest would be taken in the project.

Thus it was a foregone conclusion that, in March 1943, Bristol Aeroplane Company should have been selected as the contractor for what was to become the Brabazon airliner project. Curiously, this firm had been left off the invitation list to a meeting with Colonel Llewellin in January 1943 to discuss the Brabazon Type I specification, but chief designer Leslie George Frise BSc, FRAeS took care that the company was not left out in the cold. His company had done more work than any other on the project to build a huge bomber

An artist's impression of the projected '100-ton bomber' as it was in November 1942, showing the buried engines and access to the wing from the main body of the aircraft. (BAC)

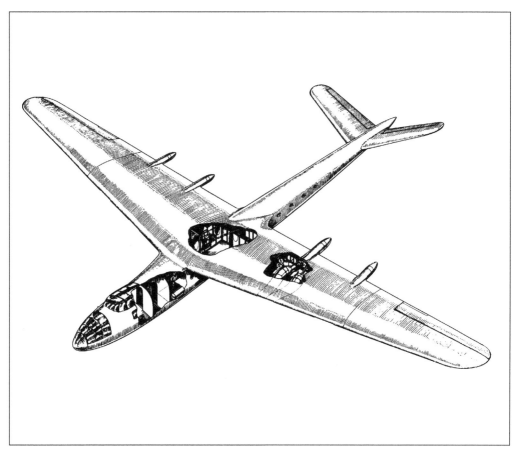

of 5,000 miles' range, which had finally ground to a halt in November or December 1942. Further massive points in Bristol's favour were that it could produce both the airframe and engines, and also had the spare capacity. The firm was also rated above average on structural design. So Sir Archibald Sinclair, the Secretary of State for Air, announced the project in the House of Commons as the Bristol Brabazon Type I on 11 March, on condition that other work would not be affected.

In April Sir Wilfred Freeman sent the formal invitation to the Bristol Company and asked for the firm's views on allocation of the sub-contracts necessary to get so large an aircraft built. The company submitted a memorandum and on 29 May the Ministry issued an instruction to proceed for two prototypes with a maximum of ten more production aircraft in view, although materials were to be ordered only for the prototypes.

The project became public on 30 June 1943 and the news rapidly reached all corners of the British Empire. In New Zealand, the *Evening Post* said:

> The Ministry of Aircraft Production has authorised the Bristol Aeroplane Company to begin work on the world's biggest airliner. The company's chief engineer and designer, Mr Leslie G Frise, planned the airliner, which will weigh 130 tons and incorporate many of the theories which were put into the

Two early models of the Bristol Type 167, the one above being with pusher propellers and a vee 'butterfly' tail. The version below dates from late 1945, just before the central undercarriage leg was abandoned.

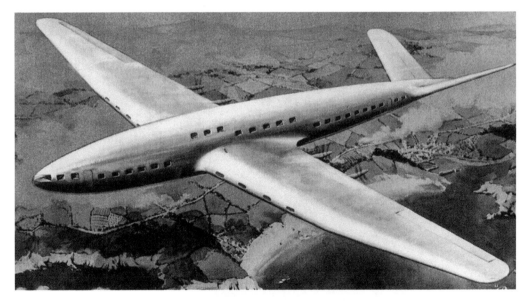

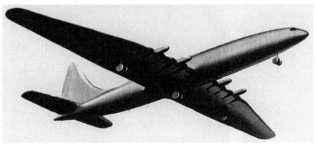

Beaufighter and other war planes from the Bristol factory. Mr. Frise's airliner will require a three mile runway, to take off and probably, in addition, a five-mile clearance round the field for climbing and approaching. Its production will not be permitted to interfere with the company's output of war planes.

Like the Convair B-36, which was started earlier, the giant Bristol bomber was planned to use big air-cooled piston engines buried within the deep wing and driving pusher propellers. It was even more powerful than the original B-36, with eight 2,500hp Centaurus sleeve-valve engines arranged in four pairs, driving four contra-props to minimise the span-wise spread of the engines and keep all four pairs within a wing section deep enough to accommodate them.

The buried installation was intended to reduce drag by about 25 per cent, although Sir Roy Fedden, who had designed the engines, recommended neither buried nor coupled engines and said it would be much better to use six of his forthcoming Orion two-shaft turboprops, each driving a single propeller. It was a good thing they did not – the Orion did not eventually run for the first

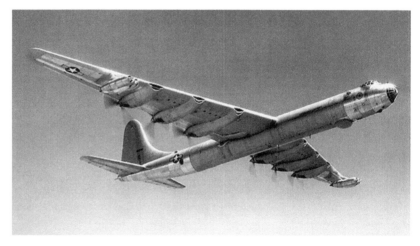

Convair's massive B-36 bomber had six piston engines and was later fitted with a further four jet engines in pods slung under the wings. Convair subsequently developed a cargo version designated the C-99. There were also plans for a civil variant of the XC-99, the Convair Model 37, a large passenger aircraft which was never built. The Model 37 was to be of similar proportions to the XC-99: 182ft 6in length, 230ft wingspan and a high-capacity, double-deck fuselage. The projected passenger load was to be 204, and the effective range 4,200 miles. There were strong design concept similarities between the Convair and Bristol designs. (Both Convair)

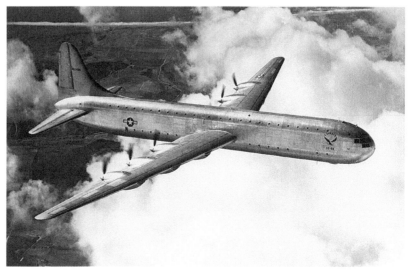

time until 1959! Another questionable feature was the butterfly tail. All these features were, nevertheless, carried across to the Bristol Type 167. A Bristol artist's impression of June 1943 showed a slender, finely streamlined fuselage (with long shallow windows directly contrary to pressure-cabin theory) mounted above the wing, but in all other main respects it was just like the 100-ton bomber.

Right from the start, Frise insisted that 150,000lb was nonsense and planned for a 250,000lb gross weight similar to the bomber. This had the effect of increasing the payload to 58–72 passengers westbound and 100 eastbound, though at all times BOAC wanted fewer passengers and in 1944 even minuted a wish to return to a mere twenty-five. BOAC thought that passengers would not tolerate a non-stop flight longer than eighteen hours, and recommended 200cu ft per passenger for ordinary comfort and as much as 270cu ft for luxury travel. It was generally agreed that a high standard of comfort should be provided for as many passengers as possible, and that the air-conditioning system should ensure an equivalent cabin altitude no greater than 8,000ft when flying at 35,000ft.

The first layout in April showed a body of 25ft diameter divided by a level floor into two decks, with sleeping berths for eighty passengers, together with a dining room, promenade and bar; alternatively there were day seats for 150 passengers. The sleeper version was preferred as a paying proposition because a supplementary fare for sleeping berths was acceptable; passengers also needed less food and entertainment while sleeping and the weight penalty of air conditioning, sanitation, food and water for seventy additional day passengers was substantial.

It was clear that the drag of a 25ft body was too high and a single-deck layout of 20ft diameter was thus examined. This provided a bar and promenade, but no dining room, for fifty-two sleeping passengers or ninety-six day passengers. Both the Ministry of Aircraft Production and the second Brabazon Committee – including representatives of the aviation industry and BOAC – favoured a medium-sized body associated with a fairly high speed. As such, on 5 August 1944 the committee recommended the adoption of the company's proposal for a fifty-passenger aircraft of 250,000lb all-up weight, to be defined by 'Specification 2/44'. BOAC promised support for this layout, although they preferred a smaller one for only twenty-five passengers.

A small civil project team was established at Ivor House, Clifton, and they undertook extensive preliminary layout work to determine the best arrangement of power plant and landing gear, as well as interior accommodation. By November 1944 the main features of the Bristol Type 167 design were crystallised, with four pairs of coupled Centaurus engines mounted forward of the front spar driving co-axial tractor airscrews; a conventional tail unit; a fuselage maximum diameter of 16ft 9in – the slimmest of all studied; with a single deck which went upstairs to climb across the thick wing. The designation Type 168 was reserved for a possible military variant, but no design work on this was ever done.

During 1944 the engines were relocated across the front of the 100ft-long centre section, with air intakes in the leading edge and exits above and below.

Each engine toed in at 32° to drive either the front or rear unit of the co-axial 16ft diameter Rotol tractor propellers. The landing gear began as a twin-wheel, four-tyre unit in each outer bay of the centre section, then grew a third leg on the centre line and finally became a conventional tricycle gear with twin Dunlop Compacta tyres on each main leg. A characteristic of the design was the very low 'sit' on the ground; another was exceptional aerodynamic cleanliness.

The design's weight and passenger complement varied wildly, going from seventy-two up to eighty-two, provided with sleepers and having a maximum take-off weight around 285,000lb. An aircraft of this size was a huge leap forward for British manufacturers and from the start BOAC had expressed concern as to whether the Bristol Aeroplane Company would have the capability. As to the aircraft's size, BOAC's own conception was an aircraft with a gross weight of around 170,000lb.

BOAC actually got the 'minimum of 25' passengers written into 'Specification 2/44', though *Jane's* for 1945–46 gives the equally surprising seating capacity of '224 by day or 80 by night'. At least by 1945 the first prototype Bristol Type 167 (constructor's number 12759, civil registration G–AGPW and unused military serial number VX206) was firmly under way in a shop at Filton that looked more like a shipyard. So too were a host of supporting programmes to help the airframe, engines, systems and equipment.

Design progress was slow during the war years but it soon became clear that the aircraft would be under-powered with Centaurus engines. In November 1945 the Ministry of Aircraft Production put forward proposals for fitting the more powerful Proteus turbine engines. In February 1946 BOAC officially told the DGCA (Director General for Civil Aviation) it was prepared to support an order for three Brabazon Type I aircraft with Proteus engines, subject to a number of reservations (these included a revised fuselage design to enable the most economic use of the aircraft). BOAC's request for a double-deck design was studied but rejected, and from then on only a single-deck fuselage was considered. Treasury approval for three aircraft was given early in 1946, but a great deal of design work remained to be done and there were inevitable changes in the expected payload and numbers of passengers able to be accommodated.

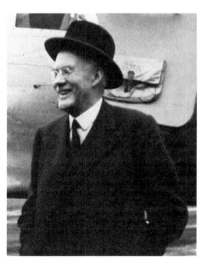

Sir Harold Brewer Hartley KCVO, CBE (3 September 1878–9 September 1972). Hartley had been chairman of Railway Air Services and later moved over to BOAC and BEA.

On 27 November 1945 Sir Harold Hartley wrote to the minister setting out BOAC's views on the Brabazon Type I and on the Saunders-Roe SR45 flying boat design. On both aircraft the chairman said that the corporation took the view that they must be regarded as national experiments. The grounds for this view were that the Brabazon Type I was far larger than any civil aircraft in operation or even contemplated in the future, that it was powered by a radically new type of engine with unknown performance and it was to fly at a very high altitude which presented unexplored problems. Consequently, no commercial airline could contemplate its purchase at that stage. BOAC was prepared to collaborate in the development of both types

in the overall interests of civil aviation and would be ready to operate either or both, subject to their being airworthy and technically suitable for operation on the routes, and provided they did not fall 'materially below the standard of aircraft operated by our competitors'. They went on to state, however, that a subsidy should be paid if the aircraft was not as economically or as commercially attractive as any aircraft of the time that could be purchased in the open market.

The minister responded on 15 December, saying that he agreed with the views Sir Harold Hartley had expressed and specifically: 'I agree that these two types are to be regarded as national experiments.'

The Flying Boat Option

Operating almost as a parallel maritime project to the Bristol Type 167 landplane design was a huge new flying boat. In 1945, Saunders-Roe of Cowes in the Isle of Wight was asked by the Ministry of Supply to bid for a long-range civil flying boat for BOAC, who planned to use it on transatlantic passenger services in the tradition of their famous pre-war C Class flying boats. Saunders-Roe's bid was successful, and it received an order for three aircraft in May 1946.

At that time there were still strong opinions that large, passenger aircraft flying boats were the way to go. Many still clung on to the 1930s ideas, whereby flying boats had made regular air transport between the US and Europe possible, opening up new air travel routes to South America, Africa and Asia. Foynes in Ireland and Botwood, Newfoundland and Labrador were the termini for many early transatlantic flights. Where land-based aircraft lacked the required airfields to land, flying boats could stop at small island, river, lake or coastal stations to refuel and resupply.

Indeed, it is not surprising that there was much interest at the time in large flying boats as well as large landplanes such as the Brabazon. In the US, Howard Robard Hughes Jr – certainly one of the most influential aviators in history – had designed and built the Hughes H-4 Hercules, irreverently and incorrectly nicknamed the Spruce Goose by the media. It was a prototype heavy transport aircraft constructed by the Hughes Aircraft Company. This flying boat was originally designed for military use, but clearly there was the

BOAC had been operating a number of Boeing 314 Clipper flying boats over the Atlantic during the war years. (BOAC)

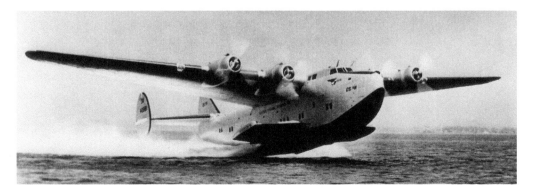

Registered NX37602, the eight-engined, 319ft 11in wingspan H-4 Hercules is made ready for its one and only flight.

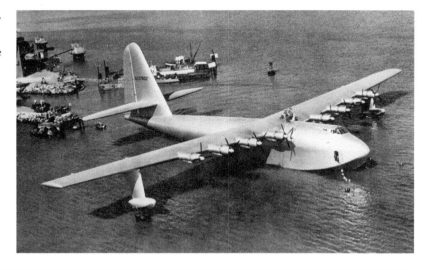

With Hughes at the controls, the H-4 flies at an altitude of 70ft at a speed of 135mph for around 1 mile on 2 November 1947.

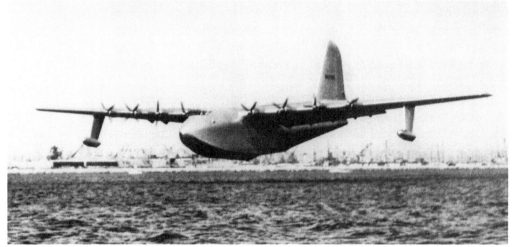

underlying possibility there for it to be used for civilian purposes. The aircraft made its only flight on 2 November 1947 and the project was never advanced beyond the single example produced. The Spruce Goose remains the largest flying boat ever built, with the largest wingspan of any aircraft in history.

Meanwhile, Saunders-Roe named their SR45 design the Princess. The flying boat was powered by ten Bristol Proteus turbo-prop engines, in turn powering six propellers. The four inner propellers were double, contra-rotating units driven by a twin version of the Proteus, the Bristol Coupled Proteus. Each engine drove one of the propellers in a similar manner to the Centauri of the Bristol Type 167. The two outer propellers were single and powered by single engines. The rounded, bulbous, 'double-bubble' pressurised hull contained two passenger decks, with room for 105 passengers in great comfort.

Despite advances during the Second World War of airfield runways and facilities, many still hankered for the glamour and prestige of the C Class and the clippers. It was soon realised, though, that the ability to land on water was less of an advantage owing to the considerable increase in the number

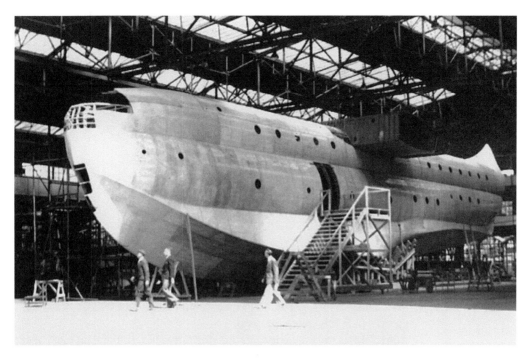

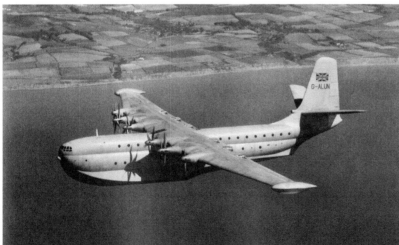

One of the three Saro Princess flying boats under construction at Cowes on the Isle of Wight.

Princess G-ALUN during an early flight.

and length of land-based runways, whose construction had been driven by the needs of the Allied forces during the Second World War. Further, as the speed and range of land-based aircraft increased, the commercial competitiveness of flying boats diminished; their design compromised aerodynamic efficiency and speed to accomplish the feat of waterborne take-off and alighting.

In 1951 BOAC changed its mind about its needs and decided it had no requirement for the Princess. It was then announced that construction of the three aircraft would continue as transport aircraft for the RAF. However, in March 1952 it was announced that while the first prototype would be completed, the second and third would be suspended to await more powerful engines. The prototype, G-ALUN, first flew on 22 August 1952 in the hands

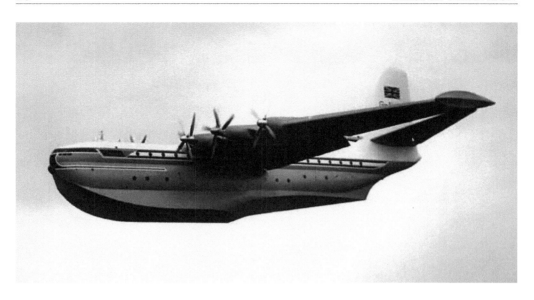

The aircraft was later painted in striking house colours to appear at the Farnborough Airshow.

of test pilot Geoffrey Tyson. Three more flights followed that week before it appeared at Farnborough that year.

G-ALUN was the only one to fly, making forty-six test flights in total, about 100 hours' flying time. It appeared at the Farnborough Airshow in 1953.

This left the Bristol Type 167 as the UK's only large passenger air-transport machine.

2

WE WILL NEED ...

There had been suggestions by the powers-that-be that the Brabazon would demand a special site. The wartime Beaufighter shadow plant at the pre-war civil airfield at Weston-super-Mare had been considered, but after surveying it was discovered that the subsoil was unsuitable for a runway of the strength required. As a result, in 1946 the decision was taken to build all Bristol Type 167 aircraft at Filton. This was only after a lot of discussion at Cabinet level, however, as approval was needed to construct a new bypass road, destroy most of the village of Charlton and for John Laing Ltd to build a very strong concrete runway across the old Filton airfield. This would stretch out to the west for 8,175ft – at the time considered an extraordinary distance – with a width of 300ft, twice that of standard RAF runways.

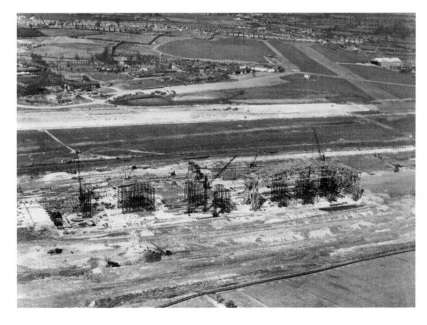

The new runway and steelwork for what was to become known as the Brabazon Hangar starts to appear at Filton. (BAC)

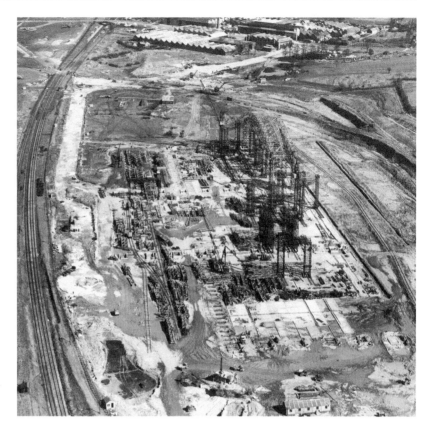

Three views of the new assembly hall at Filton built by McAlpines, with the new John Laing-built runway behind. (BAC)

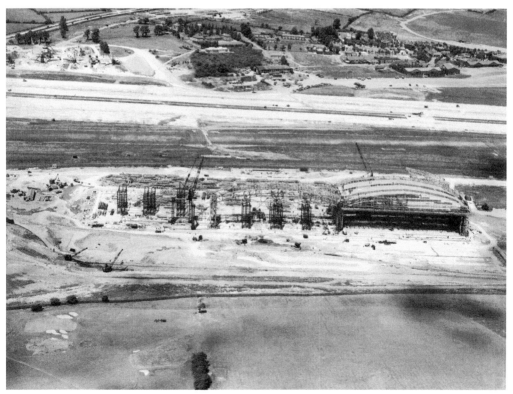

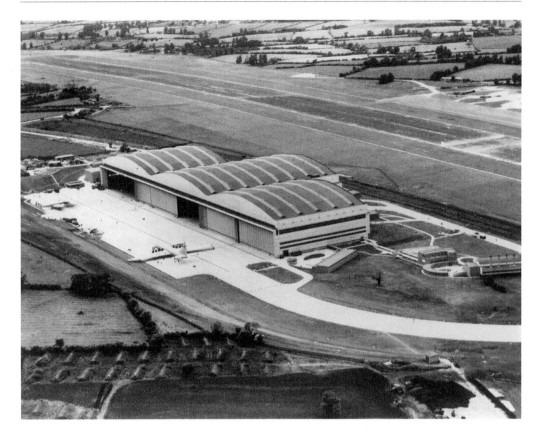

Not to be outdone, Sir Robert McAlpine Ltd also built a new assembly hall with three bays like huge lofty rooms and a frontage of 1,054ft. Its designer, T.P. O'Sullivan, won the Telford Premium Award for the work, which is still considered an amazing building even today. The architect responsible for the design of the building was Eric Ross, ARIBA. D. du R. Aberdeen and P.N. Taylor were the planning and design assistants, while the consulting engineers were Brian H. Colquhoun & Partners.

A profusely illustrated brochure called *The Brabazon Project* (the title was in gold script on a grey cover) contained colour prints by artist Terence Cuneo CVO, OBE. He was born 1 November 1907 and passed away on 3 January 1996. His parents, Cyrus and Nell, were both artists who met while studying with Whistler in Paris. Terence Cuneo studied at the Chelsea Polytechnic and Slade School of Art and became an illustrator for a number of magazines and book publishers. During the Second World War Cuneo joined the army and became a sapper but also worked with the War Artists Advisory Committee, and in this role he produced illustrations of various factories during the war and other wartime events. Soon after the end of the war, Terence Cuneo was commissioned to produce a series of paintings of railways and their locomotives. This was followed by being appointed as the official artist for the coronation of Queen Elizabeth II in 1953, which helped promote him to a worldwide audience, and a number of major commissions followed. An interesting trademark Cuneo included in his paintings was a little mouse.

The Bristol Aeroplane Company described the improvements made at Filton: 'The new Assembly Hall at Filton, conceived and built as an integral part of the Brabazon project, is the largest and most modern building of its type in the world.' Designed for the construction of Brabazon aircraft, and for use as their flight-testing base, it could accommodate with ease far larger aircraft. Apart from the main aircraft assembly hall itself, the site held a canteen, boiler house, sub-stations and other service buildings.

Site work began in April 1946 but was severely delayed by the bad weather of early 1947, so that by the time the Brabazon Type I was moved into the east bay in October 1947 it was the only one that was ready. During construction it was decided to make the west bay available to the BOAC as their Atlantic division maintenance base. Work began on additional buildings in April 1948, and the whole scheme – including all ancillary buildings – was completed in September 1949.

The structure was adopted after systematic investigation of all the possibilities for roofing the great spans required. Steel trusses spaced 50ft apart, in the form of two pin arches tied at the haunches, spanned the three bays at 345ft centres. The centre bay supports nested within those of the side bays to effect the maximum economy in the floor space required by the supports. The centre erecting *This view at dusk* bay of the hall was provided with a craneage system slung from the roof, which *from non-airside* permitted two 12-ton cranes to travel three-dimensionally over the bay. The only *shows two of the* limitation was that both cranes might not be under the same roof arch when *three bays of the* loaded. Tiers of galleries with stair and lift accesses were stacked between the *new assembly hall* main structural supports for offices and light stores accommodation.

illuminated from the inside. (BAC)

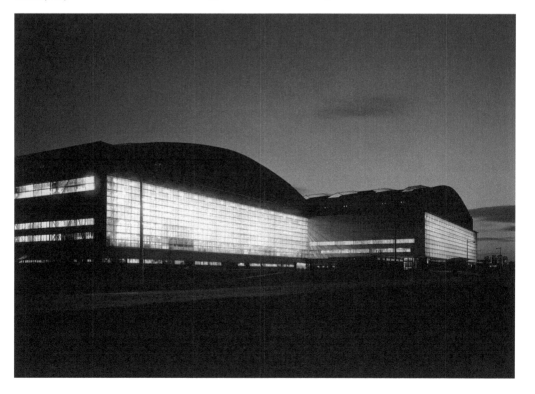

Airside of the hangars at Filton was a huge aircraft parking area. (BAC)

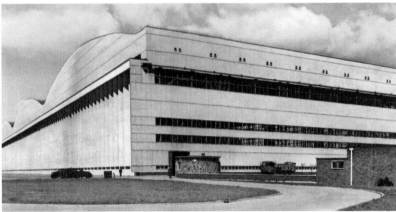

A ground-level view of the assembly building; its enormity dwarfs people and vehicles. (BAC)

The enclosing walls of the building were designed to ensure speed of erection and economy of labour. Thus the whole of the wall cladding, other than glazing, was of asbestos-cement panels, while the roof was of prefabricated steel decking panels. Internally, the hall had an insulating lining to reduce, as far as possible, the dissipation of heat through the thin skin walls.

The floor area inside the hall was 325,000sq ft, while the building itself had a total capacity of 35 million cu ft. The three bays of the structure opened on to the apron through full-width sliding and folding doors. These were constructed of aluminium alloy and were motor-operated, giving three simultaneous openings 300ft long by 64ft high.

Facing the doors at the north side of each bay was a double-glazed, 50ft-high wall, with a combined length of 1,000ft. Apart from serving as an insulating blanket, this immense wall was combined with roof and clerestory wall lighting to give comfortable daylight working conditions throughout, with a concomitant advantage of saving in electricity consumption during daylight working hours. Artificial lighting was provided by a combination of tungsten and mercury vapour lamps suspended 75ft above the floor.

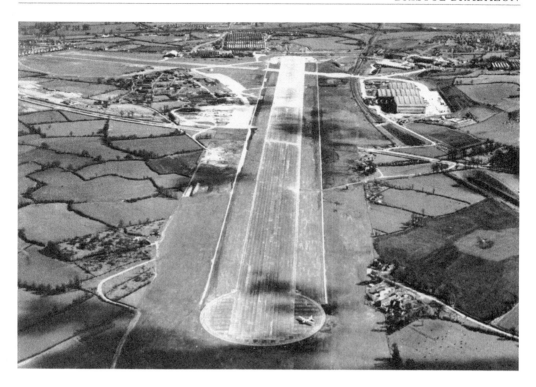

Looking down the 8,175ft-long by 300ft-wide runway. (BAC)

Economic heating was itself a major problem. The great height of the roof, the continuous doors along the south side and the necessity of keeping the whole of the floor area free from any heating panels (to maintain the maximum flexibility in the layout of the working area) were decisive factors in the development of the adopted system. Heat was required to maintain an internal temperature of 65°F (18.3°C) in winter. Cleaned and heated air from central fan chambers was distributed over the hall through ducts and was discharged across the bays from the sides through nozzles. These nozzles were placed at varying heights to form strata of warm air, and were blanketed to avoid rapid dissipation at high level in the roof. In summer, air for cooling could be introduced through the fans when the heater batteries were shut down.

Linked to the hall on the east side were a number of ancillary building: a main administration block, a works canteen and a block of staff dining rooms. The layout had been contrived to take full advantage of aspect and prospect, while the openness of the plan allowed for pleasant garden precincts to be cultivated as a counterpoint to the elegant severity of the main building.

The brochure explained:

> The doors open on to a concrete apron with an area of seven acres, which is connected with the runway by a link road and a 90 ft. wide level crossing over a branch railway line
>
> The runway itself is one of the strongest in the world and is capable of standing up to aircraft heavier than any yet built. Running due east–west, it is 2,725 yards long and 100 yards wide, with a safety strip 50 yards wide on either side and concrete turning circles 200 yards in diameter at each end. It

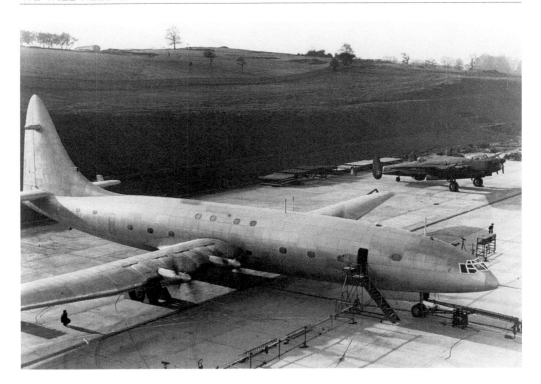

was built on the site of the existing Filton runway, 1,500 yards in length and to enable normal test flying to continue during construction, a temporary airstrip 1,400 yards long had to be built parallel to the new runway.

During the early stages of construction, some 1,000,000 cu. yds. of excavation were made, the depth of the cut varying from eight inches to fourteen feet and 400,000 tons of hard core were absorbed by the runway base alone. On top of this were laid an eight-inch sub-base of 70,000 cubic yards of concrete and a twelve-inch top layer of 105,000 cubic yards of fine concrete.

Work on the runway proper was completed in March 1948, but the transfer of the B.O.A.C. base necessitated the provision of runway lighting comprising 140 contact light fittings at 100 ft. intervals, each with a strength of roughly 1,000 candlepower. Approach lighting extends 1,500 yards beyond each end of the runway and consists of 140-watt sodium approach lamps at 300 ft. intervals. The lights are connected as two circuits, one from each of two control houses at either end of the runway, each circuit supplying alternate light fittings to reduce the risk of the whole lighting system being 'blacked out' through a fault in one control house.

The Brabazon Type I undergoing engine runs on the huge parking apron airside of the hangars at Filton. In the background is the Avro Lancaster used for the powered control experiments. (BAC)

The history of the transfer of the BOAC engineering base at Dorval, Montreal, to the Bristol Aeroplane Company's works at Filton, Bristol, reflects considerable credit on all those BOAC staff involved in organising and monitoring the move.

It was a massive exercise carried out with the minimum of disruption to North Atlantic services. Dorval had become the main base for the Consolidated B-24 Liberators during the war and then subsequently for the Lockheed Constellations. Other things being equal, it was at that time an ideal

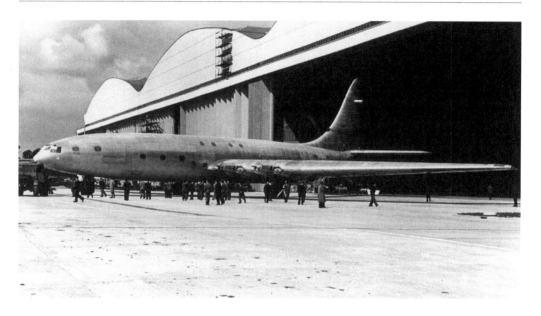

*The Brabazon seen
during one if its
moves out and in of
the new assembly
hall. (BAC)*

base: conditions in Canada were far easier than in England, spares could be more readily obtained and local staff had become experienced in coping with American aircraft. However, other things were not equal as by the summer of 1947 Britain was in the throes of a financial crisis, with an acute shortage of dollars. There was growing criticism at the dollar expenditure incurred at the Dorval base, although BOAC had pointed out there was no suitable alternative in England that could take large aircraft. Hurn was already fully stretched and the buildings there were inadequate to deal with existing operations. Apart from that, there was a serious housing shortage, which would make it almost impossible to find accommodation for the transferred staff.

Political pressure increased and in September 1947 a meeting was held in London between the managers of the Atlantic division and officials from the Ministry of Civil Aviation (MCA) and the Ministry of Supply (MoS) to discuss the problem. The MCA representatives made it clear that accommodation at Heathrow could not be provided before mid-1950, and that date would not ensure enough available housing for BOAC staff. A working committee was set up and it established that Filton was the only possible solution. This would require hangars and workshops planned for use in the production of the Brabazon to be allocated to BOAC. It was proposed to earmark one bay of the large three-bay hangars at Filton for BOAC's needs. Although the MoS opposed this on the grounds of the possible effects on the Brabazon's progress, the MCA were prepared to accept any resultant delays and the Bristol Aeroplane Company gave their consent.

On 5 December 1947 the proposal to use Filton was announced in London, and approved formally by the BOAC board on 8 January 1948. Government consent was given only on the understanding that BOAC would have to bear the expense of the move and of setting up the new base. This hard-line decision meant that BOAC would have to cover the cost of the actual move from Dorval, the construction of workshops and offices, and the laying on of

The Brabazon assembly hall
and ancillary buildings.

1 Boiler House
2 Kitchen Yard
3 Canteen
4 Covered Walkway to
 Canteen
5 Covered Walkway to
 Inflammable Stores
6 Inflammable Stores
7 Toilets
8 Pump House
9 Esavian Doors
10 Concrete Apron
11 Car Park
12 Cloakroom
13 Main Entrance Hall
14 Fire Station
15 Truck Charging
16 Electric Sub-Station
17 Maintenance Block
18 Main Goods In
19 Compressor House
20 First-aid Unit
21 Heat Treatment and
 Anodising
22 Acid Treatment
 Building
23 BOAC Workshops and
 Offices
24 Gatehouse
25 Bus Terminus
26 Bicycle Sheds
27 Chauffeurs' Rest Room
 and Garage
28 Waste Metal
 Compound
29 Inflammable Stores
30 Fuel-Storage Tanks
31 Fuel Tanker Garage
32 Aircraft Fuelling
 Points
33 Static Water Tank
34 Link to Airfield
35 Level Crossing
36 Gallery Offices
37 BOAC Maintenance
 Bay

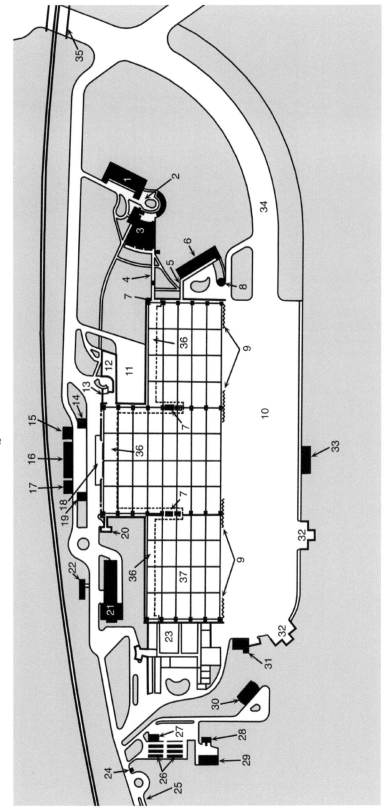

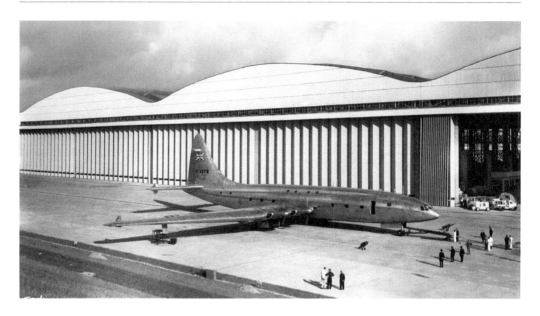

public services, together with all the costs of bringing the airfield at Filton up to the standard required for regular day and night operation. This involved putting down landing aids, airfield lighting etc. and even bearing the cost of the salaries of the MCA airfield personnel.

The plan was to house and maintain at Filton the six Stratocruisers the corporation would be acquiring, hopefully in the spring of 1948; Dorval would continue to look after the Liberators and the Constellations until later in that year. So in due time Filton was to be the main maintenance and overhaul base for all these aircraft, until Heathrow was ready to take them.

The building contractors started work in April 1948, while BOAC's administration department had the daunting task of finding housing for its staff within reasonable distance of Filton. It was thought that around 350 houses were required, and they had to be found in the middle of an acute housing shortage. Eventually a solution was found by setting up pre-cast, concrete-block houses built by the Bristol Aeroplane Company at a cost of £100,000. Much of this work was later costed into the overall Brabazon Type I budget.

The Brabazon project detractors, both at the time and later, would include the cost of the construction and development of these facilities at Filton in with the aircraft itself, conveniently forgetting that these assets would be used for other projects, including the Britannia, Concorde and Airbus.

3

CONSTRUCTION

The Bristol Type 167 was the last aircraft designed under the leadership of Leslie G. Frise. The detailed layout was done by an ad hoc team at Ivor House, Clifton, which had been one of the company's wartime dispersed design offices.

Wartime conditions of production, under which rapid building and large output were primary considerations, accustomed the aircraft industry to the sub-assembly principle, whereby the complete structure is broken down into main components and then successively into smaller and smaller units. Such a system, by permitting manufacture to be carried on simultaneously by a large number of people, certainly shortened the assembly time and reduced to a minimum the numbers of workers needed in the final assembly stages on the complete structure.

However, this method could not be adopted with any advantage in the building of the Bristol Type 167. In the fuselage, for example, a number of transport joints would be required, which, apart from increasing structure weight, would have increased enormously the problems of pressurisation. More elaborate tooling would have been needed, with separate fixtures and fixture references, to control the accuracy of assembly for mating the sections. Quite elaborate equipment for manipulation and very strong floor foundations would also have been required for the mating operation. In view of all these factors, the shipbuilding method of constructing the entire structure in one piece offered the best solution and it was decided to construct the complete fuselage of the aircraft, with the centre section of the mainplanes and the tailplane as a single, integral unit.

For the first machine, the outer portions of the mainplane – from the outboard ends of the centre section to the wing tips – were necessarily built as separate components, as, apart from structural considerations, a shop large enough to house the complete span of 230ft did not exist.

The wing was made long, slender and very thick, with a thickness/chord (t/c) ratio of no less than 21 per cent! This fitted round the big engines and

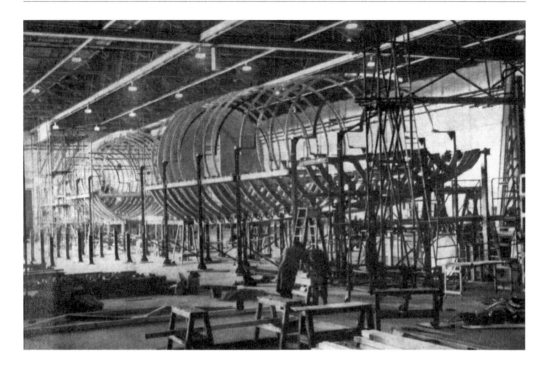

A view of the fuselage during the early stages of assembly also shows the cradles and top-longeron support arches of the fixture, and gives a good impression of its size. (BAC)

offered low, induced drag for long-range cruise at 250mph. Frise also went to inordinate lengths to keep down the weight. Most of the bending loads were taken by evenly spaced stringers of extruded Z-section all round the periphery, and because of the great depth of wing the skin was nowhere thicker than 0.185in. Great care was taken to hold exact skin thicknesses, and rivets were individually trimmed to length.

This need to minimise weight and drag governed the entire design. The two objectives worked together in making the wing thick, but resulted in power plants grouped closely inboard instead of being distributed across the span. More seriously, aerodynamically the wing was too 'fat' for cruising speeds significantly greater than 250mph, and this hurt future development with turbine propulsion. It also offered so much room that the 13,660 imperial gallons of petrol were easily housed in twenty-eight bag tanks in the inter-spar box of the outer wings, with the innermost tanks 50ft from the fuselage.

In their brochure, the Bristol Aeroplane Company made particular mention of the reversible pitch propellers:

> The Rotol Propeller installation for the Brabazon Mark I, now flying, comprises of four pairs of three bladed co-axial propellers powered by eight Bristol 'Centaurus XX' engines.
>
> As distinct from the Brabazon Mark I installation, the Mark II aircraft, powered by four coupled Proteus engines is equipped with Rotol 8-blade counter-rotating hydraulically operated propellers. The propellers, incorporated in an aircraft of such advanced design, consist in the main of constant-speeding, feathering, reversing, fully automatic synchronising,

internal electric de-icing of blades and spinner, and the provision of pitch safety locks. Constant-speeding, whilst being a feature of some years standing, has been given special consideration in relation to the control characteristics of the gas-turbine power unit.

Reversing has also received close attention in order to provide a sufficiently fast rate of pitch change into reverse to meet the I.C.A.O. 'start-stop' requirements. The fully automatic propeller synchronising is fully established on operational aircraft including the Brabazon I. There is every indication that automatic synchronising will be an essential, with gas-turbine power units, in avoiding irritating beats, which will now become the major discomfort with the relatively quieter power unit.

The propeller blade construction is of the Composite Type, wherein a basic duralumin blade has a hollow metal leading edge, thereby permitting the electric de-icing element to be fitted internally, instead of externally, as hitherto. This internal fitment of the element entirely eliminates the aerodynamic efficiency losses associated with an externally fitted element.

Mechanical safety pitch locks are incorporated in the propeller operating mechanism, to prevent any serious propeller and/or engine overspeeding in the event of a control failure. Two locks are provided, one being located just below the cruising pitch and the other at normal take-off pitch. Both locks are automatically removable, the cruising pitch lock at the time the flaps are

T-167/93, the ninety-third photograph of the Bristol Type 167. So went the numbering system on all Bristol Aeroplane Company photographs. This shows the framework of the Brabazon fuselage coming together in the old assembly shop. The date is believed to be sometime during the winter of 1945/46. (BAC)

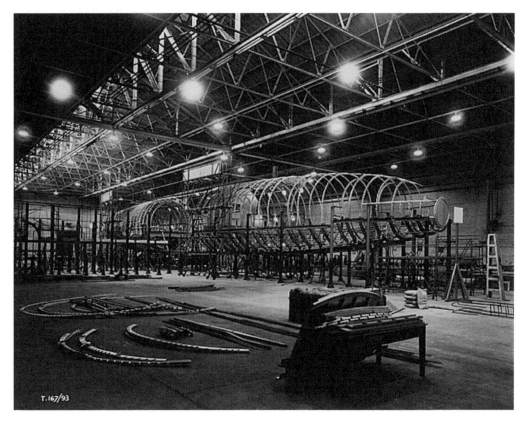

T.167/93

lowered and the take-off pitch lock when the reverse pitch control for landing braking is operated.

The propeller control system also caters for the conditions of ground refrigeration wherein high engine R.P.M. with low thrust is required. The general design of the propeller mechanism has been studied to give quick fitting and removal from the power unit, also for minimum replacements at major overhauls.

The Structure

Contemporary reports described the aircraft in some detail:

> ... in overall configuration the Brabazon I (Bristol 167) is surely, and irrespective of class, one of the most graceful aircraft ever to take the air. The wing, however, is of inordinate thickness in order to accommodate the Centaurus engines, and, although weight-savings will be effected in the Mk. II wing, the thickness will not be decreased.

The intersection of the main fuselage centre bay and inner wing. This illustration also shows the diaphragm, which replaced the open bracing of the front main inner-wing spar across the fuselage.

Though a fuselage of 'figure 8', or 'double-bubble', cross-section would offer floor space for extra payload, should stops be made at Gander and Rineanna (Shannon), two important effects would arise from its adoption. The first was that the weight of the fuselage, floor, furnishings, pressurising and other equipment would be increased in proportion to the accommodation. Secondly, the wing structure weight would be greater due to the increased bending moment resulting from the transfer of load from the fuel tanks to the body.

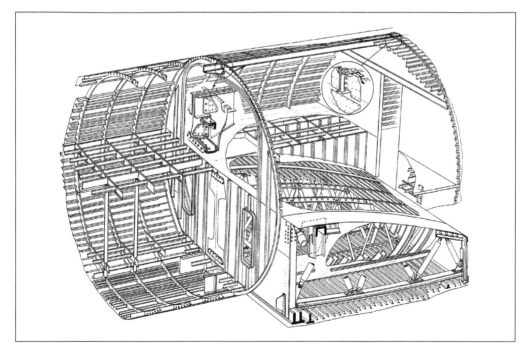

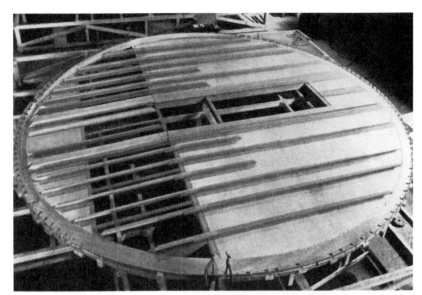

(Left) The assembly table for frame 0 at the point of the fuselage where the rear mainplane spar is taken through. The lower part of this frame is inclined at an angle of 3.5° to match that of the spar.

(Below) The front pressure frame in position on the fuselage is supported by the assembly fixture. (Both BAC)

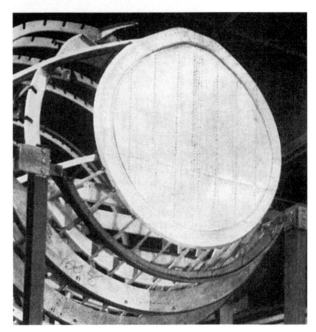

The choices for the Atlantic, as Dr Archibald E. Russell, the company's chief designer, pointed out, appeared to be a single-deck fuselage capable of making the non-stop westbound Atlantic crossing with sleeping accommodation for all passengers, and with a payload amounting to about 8 per cent of the all-up weight; or seating accommodation for 50 per cent more passengers, probably on a stopping service. Alternatively, there could be a double-deck fuselage, unsuitable for the non-stop westbound crossing but with sleeping accommodation appropriate to a passenger payload equivalent to 12–13 per cent of the all-up weight on the stopping service, and with considerably more seating capacity on alternate, shorter runs.

The Bristol Company's conclusion was that, for aircraft of about 300,000lb gross weight, a double-deck fuselage was not the best arrangement if a range exceeding 4,000 miles was a primary requirement, and that a single-deck body gave greater flexibility for alternative passenger arrangements until conditions of transatlantic operation became better established.

The fuselage skin of the Brabazon Type I was carried on a series of Z-section stringers and rolled U-section frames. Three sizes of Z-section stringer were used: two made from extruded material and one from rolled stock, in order to keep a very careful watch on strength-to-weight factors. The heavier of

The centre bay of the fuselage, looking forward. The mainplane centre section ribs can be seen in the foreground, and beyond is part of the mezzanine floor which would be carried over the centre section. (BAC)

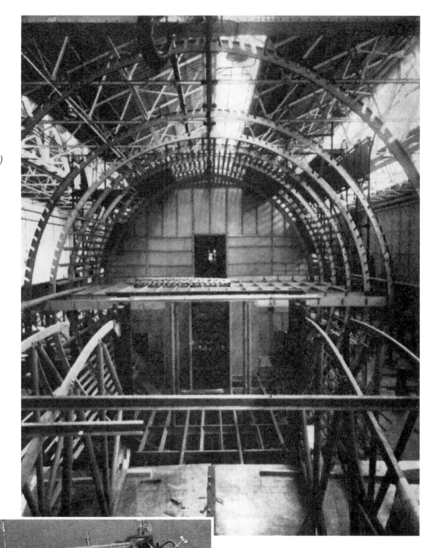

The windscreen structure of the Bristol Type 167 in its assembly fixture. (BAC)

the two extruded types was used in the central part of the fuselage and in the area of the wing centre section where the greatest bending moment occurred.

These heavier stringers terminated with adjacent pairs gathered into a Y-fitting, at the base of which the lighter extruded stringers picked up. Positioning of these Y-blendings was roughly at the centre section's leading edge forward, and a few feet rearward of the centre section's trailing edge aft. In the rear half of the fuselage the lighter extruded stringers were used, but in the forward half they extended to about 18ft forward of the leading edge. At this point they gave way to the lightest rolled stringers, which continued up to the nose.

After the skinning of the fuselage was completed, it was decided to increase the torsional and flexural strength by connecting the frames to the stringers by a series of cleats, extending through the main fuselage and rear body. Attachment was made at the points where the stringers passed through the cut-outs cropped into the outer frame periphery.

There was an almost constant preoccupation by the designers with saving weight by paying great attention to detail. The extruded stringers, for example, had their free flanges taper-machined. In the centre section trunk of the fuselage alone there were 132 stringers, and that machining gave a weight saving per stringer of around 6 per cent. This machining also gave a tapering flange thickness to ensure a gradual change in stringer cross-section and, thus, avoided any stress concentration.

For the same reason of strength-to-weight factors the fuselage skinning varied in thickness, being 0.080in thick in the centre trunk portion and diminishing through 0.064in thickness to, eventually, 0.048in-thick panels at the extremities. The designers realised that 'bought in' standard sheets were manufactured to thickness tolerances wider than was acceptable – and that if too many sheets used were near to the top limit, then there would be an overall increase in weight that would create an expensive penalty. Special sheets were therefore rolled to tolerances intended to keep the thickness nearer the minimum rather than the maximum permitted.

There were three main longerons in the fuselage: one on the centre line of the roof and the other two low down. The ridge beam was made up of two light, rolled channels placed back to back in order to form an I-beam, but the lower longerons were L-section extrusions curved to follow the skin contour. Above and below the windows ran extruded channel stringers-cum-longerons. The

A view of the fuselage, which shows clearly the structural function of the main top longeron. (BAC)

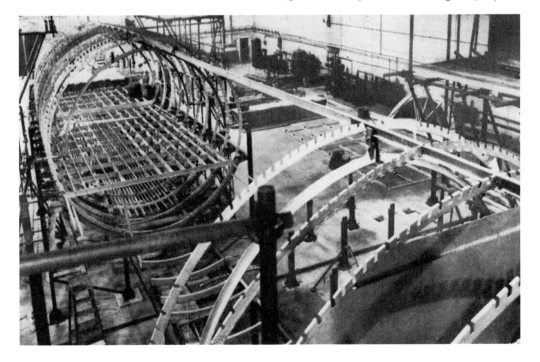

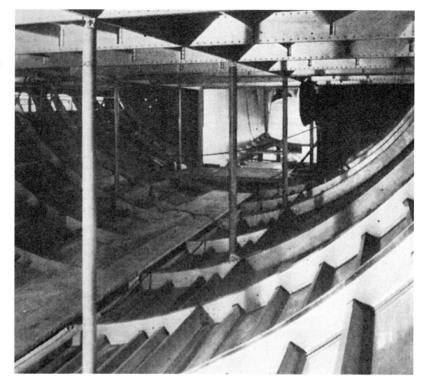

Tubular support struts for the floor were riveted between the main longitudinals and the floor structure and the fuselage shell at alternate frame stations. This portion of the fuselage had been provisionally allocated to the stowage of luggage. (BAC)

cabin floor ran at different levels; a few inches higher at the flight deck and tail end and even higher at the central trunk portion, where it was raised to a height that was tangential with the wing centre-section top surface.

A series of five bulkheads divided the fuselage. Working from the nose back, the first was at the rear of the flight deck and was made rigid on both faces with large extruded members, those on the forward face being U-section and those on the rear face Z-section. Vertical posts of U-section material – which became I-section lower down – were fitted on the rear face and picked up to the side walls of the nosewheel bay. The structure here was quite complex, for these nosewheel bay side walls picked up to the vertical flanges of the main longerons and were finished at their top edges with L-shaped extrusions forming T-booms. The nosewheel bay extended back around 11ft from the Number 1 bulkhead, and one frame aft of the well's rear transverse wall was the second bulkhead, to which the side walls of the bay reached.

Number 2 bulkhead had a mainly smooth forward face; the vertical and horizontal Z-extrusions used to make it rigid were on the rear face. However, U-section material, which blended into I-sections, was fitted vertically on the front face to pick up the nosewheel well side-wall extensions, and at about 7ft 6in above the floor an extruded lintel member was fitted.

Number 3 bulkhead was made rigid with vertical and horizontal rolled Z-strips on its rear face, and fitted with square-section, hollow, extruded doorframe posts of light gauge. Immediately aft of this bulkhead was a pair of outboard staircases leading down to the galley and a central staircase leading up to the bar lounge.

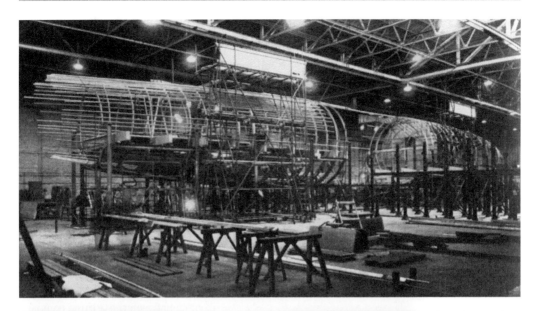

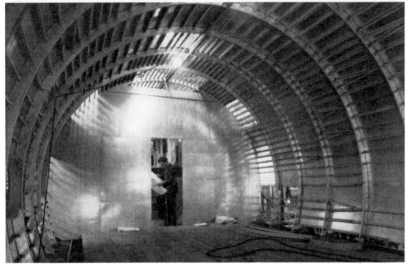

An early stage of assembly showing the frames, stringers and top longeron of the main fuselage in position.

Looking aft from the forward section of the aircraft into the galley and the stairway to the lounge or mezzanine floor. The merging of alternate stringers towards the nose of the fuselage is shown in this view, as is the manner in which the joints are staggered in the form of a V round the fuselage. (Both BAC)

Spar Seal

Roughly halfway along the fuselage, where the front spar of the wing passed through, there was a diaphragm web to provide a pressure seal. This was carried up on each side in arms to form a 'horseshoe', the tips of which were brought together on the roof centre line. The periphery of the member was edged by a large, square-section extrusion that was progressively machined away on each side to an L-section at the top and bottom. The interior profile of the horseshoe was edged by a U-section member, and to port and starboard on the forward face a box-section vertical stiffener was used.

The rear spar station was similar, in that the spar web was formed as a pressure-sealing diaphragm integral with the No 4 bulkhead. The last of the bulkheads, No 5, was the rear-pressure diaphragm, and on its forward face

were built massive box-section stanchions. To the top ends of these the feet of the fin front spar was positioned. Four frames aft of this last bulkhead was a U-frame that picked up the tailplane front spar; a further U-frame picked up the tailplane rear spar.

Joining the mainplane centre section to the fuselage presented a difficult problem to ensure adequate sealing of the fuselage internal pressure. This came about because the centre section was built as a continuous structure that passed directly through the fuselage; the front and rear spars were formed with diaphragm webs which acted as pressure bulkheads. The upper and lower centre-section skins were continuous through the fuselage and, in order to make the wing interior a pressurised compartment, extra skins were applied to the flanges of the centre-section stringers. These internal skins were riveted at their outer edges to angle members, the vertical flanges of which were in turn riveted to diaphragms known as wing-root ribs. The latter were, in essence, continuations of the fuselage skin through the wing. So there were pressurised compartments above, inside and below the wing, with cavities between these three compartments that allowed the passage of the centre-section stringers.

Outboard of the fuselage, the wing centre-section front spar was a girder structure, the bottom boom being sections created from two T-sections placed side by side, whilst the top boom was a U-section, all created from extrusions. Inter-boom bracing was by

Rib 111, a typical tubular, strut-braced interspar inner wing unit.

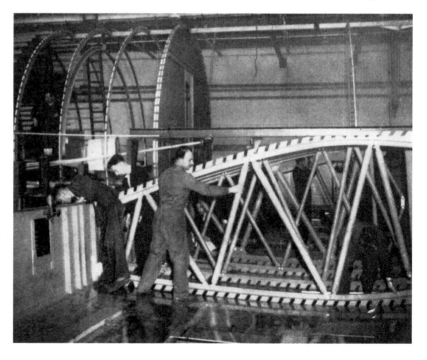

Fitting the inner wing interspar ribs. The depth of the wing section can be seen from the comparative height of the men working on the assembly. (Both Aircraft Production)

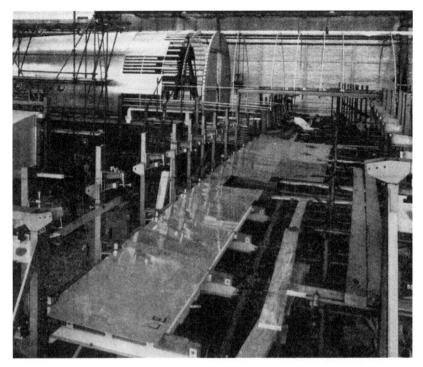

Commencement of the inner wing assembly: the under-surface skin panels are in position on the cradles of the main fixture. (Aircraft Production)

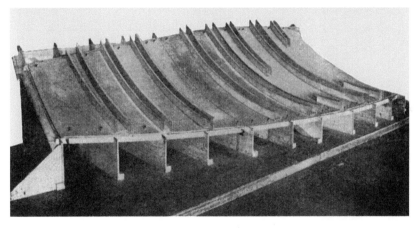

The assembly fixture for the curved body line, or fuselage ribs. (Aircraft Production)

kingpost stanchions of huge extrusions that resembled two channels placed back to back with a central spine flange. Tying these kingposts together were diagonal bracing struts of tubular steel. Behind the two T-extrusions that made up the front spar bottom boom was an extruded T-section reinforcing boom. It all looked like scaffolding on a building site!

By comparison, the rear spar was a simple structure made up of a diaphragm web with huge, extruded L-section booms. Again, in front of the bottom boom was an extruded T-section reinforcing boom to complement the front spar bottom boom.

Chordal ribs were fabricated Warren-type girder components, with tubular struts of Hiduminium bracing the contour members. These were made up with sheet webs, the internal being reinforced with Z-section extrusions,

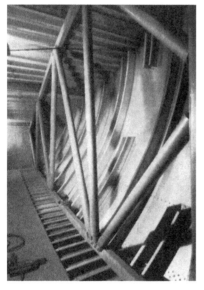

whilst the outer edges carried T-section extrusions. These T-extrusions were machined away, together with the sheet webs, to afford passage for the Z-section span-wise stringers to which the skin was attached. The chordal ribs edging the undercarriage bay were diaphragms with large stiffening members, and on the centre line of the bay the front spar kingposts were doubled. On the rear spar in this area, a reinforcing boom was fitted to the top boom of the spar, this extended 10ft 6in on each side of the centre line of the bay. At the outboard ends of the inner wing were diaphragm chordal ribs; the space between them housing fuel tanks. To complete the tank cell, the web structure of the front spar at this point was also a diaphragm.

Attachment of the outer wing panels was conventional in the fork-end and lug-pin-joint fashion – however, the outer wing panels were of very different construction. At the 15 per cent chord position was a diaphragm-type spar referred to as the front tank spar that comprised a plate web with U-section booms: this formed the front spar of the outer wing. At 27 per cent cord was the front spar continuum, which was merely a pair of booms with no web structure; this was to give tank clearance and distributed stress between the outer and inner wings.

At 55 per cent wing cord was the rear tank spar, built with conventional booms and a plate web, which extended to the outboard end of the tank position. At the 69 per cent cord was the rear spar proper, of normal plate web and L-section boom construction, which picked up with the rear spar of the inner wing and extended out to the full span.

Just as much care was taken with the skinning and close tolerances of the skin panel thickness on the fuselage; the designers applied the same care to the skin plating of the wings. The skin thickness was graded both span-wise and chord-wise, the heaviest being employed around the centre section, with each panel outboard being reduced in thickness.

The centre section was covered with 0.185in-thick sheet, the successive outboard skins reducing to 0.176in, 0.166in, 0.144in and 0.125in thick. At the outer end of the wing the final three panels were 0.125in thick attached to the front spar and 0.095in attached to the rear spar, with a centre panel 0.116in thick. These thicknesses applied to the upper surface; similar graduations were used for the lower surfaces except that the panels were slightly thinner below their counterpart on the top surface. There were, however, extensive reinforcing skins around the undercarriage bays.

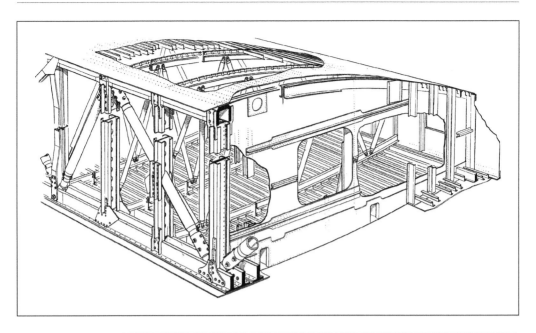

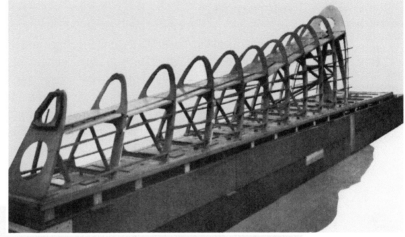

(Above) Structural details of the inner wing, showing booms and bracing of the front main spar and forward bottom longerons, or reinforcing boom, immediately behind the bottom of the spar. The rear spar can be seen on the extreme right.

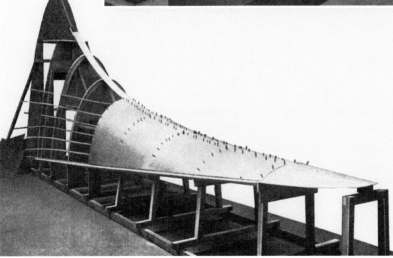

(Above) The structure of the leading edge of the fin assembled to the front spar, showing the leading edge diaphragm.

(Left) The dorsal fin unit in the assembly fixture with the skin plating partially assembled. A simple wooden fixture was used with templates at each frame station to locate the ribs. (Both Aircraft Production)

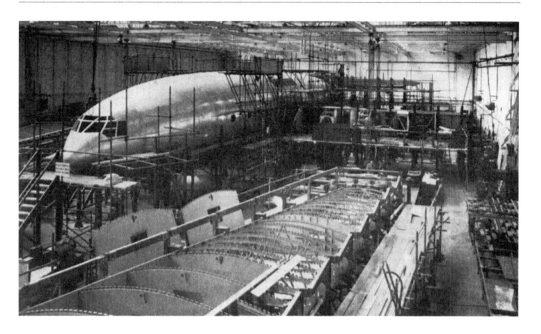

Picture T167/383
shows the prototype
Bristol Type 167, as
seen in February
1947. In the
foreground is the
starboard outer wing
component in the
course of assembly
in a separate fixture.
(Aircraft Production)

Undercarriage

As originally planned, the Brabazon undercarriage embodied two main assemblies outboard of the engines. In 1944, for structural reasons, a third leg was added under the fuselage in addition to the nosewheels, but nearly two years later, in November 1945, it was decided that the track of 94ft would limit the operation of the aircraft from runways and taxi tracks and the main legs were, therefore, moved inwards to reduce the tack to 55ft. At the same time the central set of wheels was abandoned. These alterations necessitated considerable redesign of the wing and fuselage structure, but as this coincided with the decision to fit Proteus turboprops in the second and subsequent aircraft, it was possible to take both factors into account simultaneously. The Brabazon Type I was, nevertheless, carrying a considerable amount of unnecessary weight in fuselage structure, a legacy of the under-fuselage undercarriage assembly.

The principal units of the undercarriage were two main Dowty assemblies with liquid-sprung shock-absorber units and two twin-tyre Dunlop wheels; a Dowty nosewheel assembly, also liquid-sprung, with twin steerable Dunlop wheels; and a non-retractable tail bumper in the form of a skid, again with liquid springing. The main wheels measured 63in by 35.5in and had a 90lb per sq in tyre pressure. The wheels were reinforced with rayon cord and retracted forwards into the wing. The nosewheels retracted rearwards. The Dunlop Company had calculated that the heat generated in slowing down the Brabazon's weight, when landing at anything between 100 and 125mph, was 69,500 British thermal units – sufficient to raise 4cwt of steel to blood-red heat. It was absorbed and dissipated by the brakes in less than a quarter of a minute.

For the Dunlop electro-pneumatic brake system there were sixteen main air bottles and four emergency bottles. Air was fed to the brakes through differential and relay valves, which could be operated by either pilot.

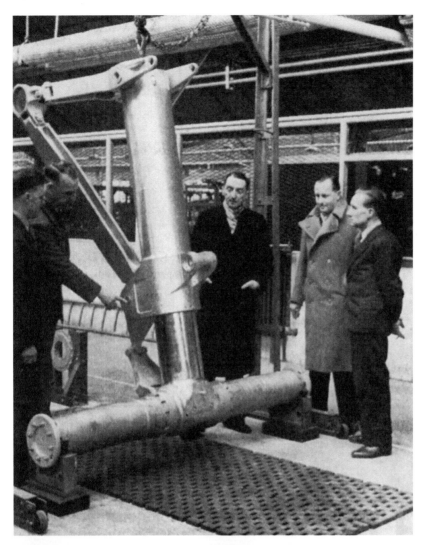

The first main undercarriage leg for the Bristol Type 167 takes shape at the works of Dowty Equipment Ltd. (Seen left to right) Messers D. Stocks, works production engineer; V.O. Levick, general works manager; R.H. Bound, technical director; George Dowty, chairman and managing director; J.R. Dexter, assistant works manager.

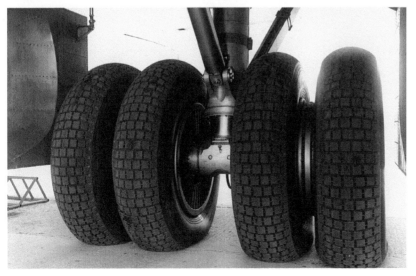

The completed unit installed on the aircraft. (BAC)

Attaching the Skin

Bristol Aeroplane Company discovered a whole series of problems associated with riveting the fuselage structure. Mushroom-head rivets were used for the attachment of skin plating – this practice evolved from the need to obtain a truly sound seal for the pressurised main fuselage. Satisfactory results under pressure conditions had been obtained with the head, although their use entailed an increase in drag by comparison with those of the flush, countersunk head type.

A full-size nose fuselage was built for the purpose of carrying out pressure tests and it was found that with the countersunk head type of rivet it was impossible to prevent a certain amount of leakage round the head. With ordinary rivets supplied from stock, the countersunk head was found to vary over quite wide limits and the design requirements of a pressurised fuselage could not be met without going to the length of using special precision rivets.

It was found that considerable variation occurred in the diameter of standard mushroom-head rivets as received at the factory. If oversized rivets had been used it was quite possible that scouring of the stem would have been the result, and the accumulation of swarf under the head would have prevented the rivet head from seating properly. Conversely, if an undersized diameter rivet had been used a slack fit would have been obtained. Both would have been bad riveting and would have prevented a satisfactory seal for the pressurised main fuselage.

The components of the Brabazon come together in the flight shed at Filton, to a point where they are ready to be moved to the new final assembly hangar. (BAC)

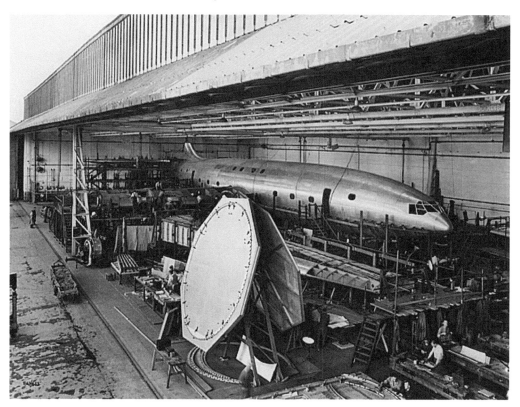

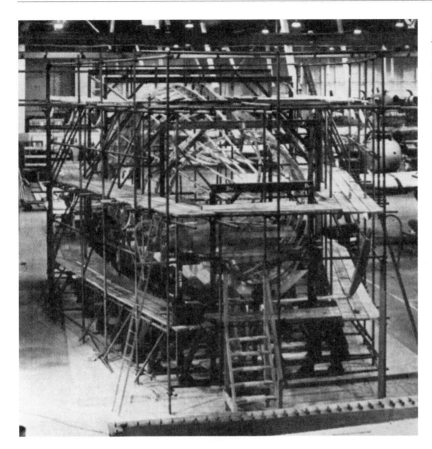

The experimental front fuselage section under construction that was used for – amongst other things – pressurisation tests. (BAC)

A series of panel tests were also carried out, the arrangements including various types of lap and butt joints and stiffener attachments. Flat panels with precision countersunk rivets showed much leakage even when sealed, and soap-bubble tests confirmed that the leakage was actually at the rivets. In further tests, panels to a typical curvature were used with mushroom-headed rivets and it was found that a bead of special rubber compound applied at the inside edges of the seams was sufficient to achieve the necessary soundness at the joints.

Sealing at the rivets was not necessary, and only isolated rivets leaked. This method of construction represented quite an appreciable weight-saving, by comparison with an inter-layer or overlag type of sealing amounting to possibly 200lb or more for the whole fuselage.

As a result, the 143ft-long pressure-hull section of the Brabazon Type I extended between pressure diaphragms at frame F.1029, forming the front wall of the cockpit, and R.680, aft of the passenger compartment. In the Brabazon Type I the maximum differential pressure was 5.5lb per sq in and the cabin altitude-equivalent at 25,000ft was 8,000ft. The decision to power the Brabazon Mk II with Proteus turboprops, with a consequent increase in cruising height from 25,000ft to some 35,000ft, necessitated the development of centrifugal blowers capable of producing a higher differential pressure than those for the Type I Mk I.

As might be imagined, the expansion of the fuselage under pressure presented formidable problems. Although under normal conditions the internal pressure difference causes an increase of only 0.5in length and 0.25in diameter, the effect of extremes of temperature (between −60°C and +40°C) caused a length-wide expansion of a full 4.5in. One square inch of leakage area over the whole fuselage was permitted.

The principal components of the air-conditioning and pressurisation system were two Marshall blowers, two coolers, three heaters, three discharge valves, four inward relief valves, a safety valve, re-circulating fans and booster fans. Air circulated from the aft hold, through a heater, for distribution through ducts to the cabins. From there it was extracted through grills in the floor and returned to the aft hold. To keep the air fresh about 25 per cent new air was added every cycle; this was collected by wing-root intakes and was fed into a mixing box with the recirculating air from the aft hold, before passing through a heater for ducting to the cabins.

Though a small amount of air was continuously escaping through joints in the fuselage plating, most of the air was displaced to make way for new air leaving the fuselage through reducing valves. These valves prevented differential pressure from building up dangerously, such as when in a dive. Should

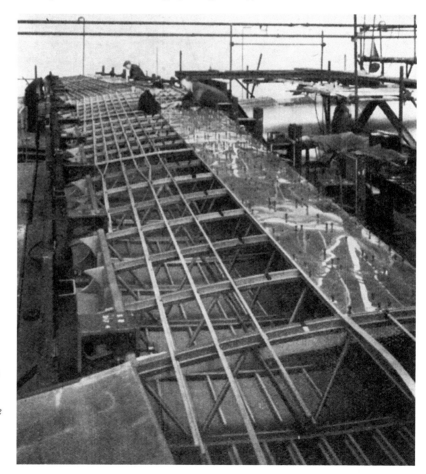

Attaching the skin to the upper surface of the tailplane: this view shows the manner in which the number of stringers were reduced towards the tailplane tips by blending them together in a Y-junction. (Aircraft Production)

cold air be required, the heater was switched off and coolers in the supply system from the wing-root ducts were brought in. In the event of failure of the two Marshall blowers, direct ventilation was obtained by opening spill valves on the main leading-edge intakes for the pressurising system.

Air entering the pressurisation intakes was filtered and passed to the blowers (driven by the inboard accessory gearboxes), which forced air on to the cold air mixing boxes of two heaters. Vibrations set up in the air intakes were dampened out by passing the air through silencers mounted in series, one in each wing and one in the fuselage. The air passed through the blowers having been compressed and heated, then to cooler units in each wing. Mass-flow units were provided to measure the flow of air. Flow was controlled by spill valves on the intake which, when opened, allowed air to escape into the wings. Twenty oxygen cylinders were also provided for emergency use.

Hydraulics

The main wing hydraulic system operated the flaps, the fire and cooling flaps and the main undercarriage by opening and closing doors, and lowering and retracting the wheels. There were four sources of power supply: two engine-driven pumps; ground connections; a hand pump; an emergency hand pump. Each of the eight flap sections was moved by a separate double-acting jack

At first glance this looks like wing structure – in fact, it is the assembly of the tailplane! On the left is one of the elevator hinge fittings with the location bracket on the framework of the assembly fixture.

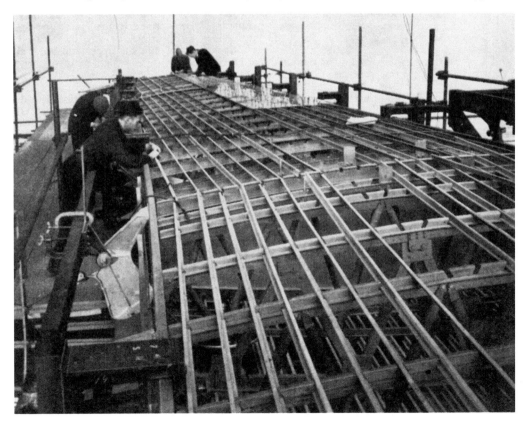

On the centre line of the fuselage, the ends of the tailplane stringers are butt-joined together and joined by cranked steel brackets, which are riveted to each side of the stringer web and to the boom of the centre-line rib. (Aircraft Production)

mounted within the wing. Normally all flap-operating valves were synchronised, but arrangements were made whereby on the early flights any one flap section could be raised or lowered independently, for example, in the event of tail buffeting.

The system for the nosewheel was used to steer while taxiing, and to raise, close and open the doors. The pilot controlled a steering motor and had a master switch for unlocking the undercarriage control lever, which was operated by the first engineer and raised and lowered the nosewheel and main wheels simultaneously. Nosewheel steering was by two double-acting, spring-loaded hydraulic jacks, the springs of which centralised the wheels on retraction.

Electrical

The main electrical installation on the Brabazon Type I was 208 V 3-phase, 400-cycle AC, with generation by six Rotax 30kVA engine-driven alternators, each of which supplied a section of the total load. About 20 per cent of the output of each alternator was transformed and rectified to cater for 28.5v DC applications on the aircraft. In the low-voltage DC circuits were two separate banks of Exide batteries, each of four 12v units coupled in series parallel, providing a total capacity of 240 ampere-hours at 24v nominal. The total weight of the batteries was 384lb.

In an emergency, the batteries were capable of giving a total output of 300 amperes for 23 minutes continuous, or 1,000 amperes for 3.5 minutes continuous.

Fuel System

With weight-saving in view, fuel tanks integral with the wing structure were originally planned for the Brabazon, but experience was limited and development difficulties proved so formidable that in April 1946 the decision was taken to change to the flexible-bag type, in the Mk I aircraft at least. Experiments with integral tanks nevertheless continued with a view to their use in the Brabazon Mk II.

The Mk I aircraft had two sets of fourteen tanks, supplied by Fireproof Tanks Ltd, with a total capacity of 13,650 gallons, of which 13,500 gallons were usable. These tanks were disposed between the spars and ribs. At the front and rear of each were branch pipes, which fed into two main trunk lines supplying electrical fuel pumps in a collector box faired in beneath each wing. In an emergency, or if the collector boxes required servicing, electrically operated

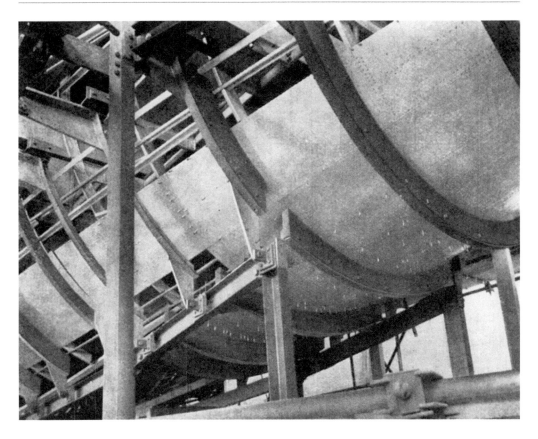

cut-off cocks could be used to isolate the boxes from the fuel bags. These cocks were shut electrically, in the event of a crash, by the action of inertia switches. From the collector boxes fuel was pumped through non-return valves and a control cock in the main supply line, from which each engine was fed.

Pressure refuelling was effected via a valve at the rear of each fuel collector box located on the underside of each wing. Intercom sockets at these points allowed verbal communication from ground engineers with the cabin. Fuel for the anti-icing heaters was delivered by a pump in each of the starboard under-wing, gravity-fed collector boxes, from which the two main fuel pumps distributed fuel to the engines. On the port side the system was extended to supply the three cabin heaters. Each anti-icing heater consumed 5 gallons per hour. The fuel system for the tail anti-icing heaters was entirely self-contained.

The fuselage underside skin panel pinned to the frames and supported by the cradles of the main fixture. (Aircraft Production)

Power-operated Controls

'Although there have been exponents of aerodynamic balancing [of controls] for the largest aeroplanes envisaged, I believe that the uncertainty of over-balance or under-balance on the first flight alone demands the use of power operation.' These are the words of Archibald Russell in his revealing lecture 'Some Engineering Problems of Large Aircraft', delivered before the Royal Aeronautical Society in 1946. It is now of interest to observe that, although the

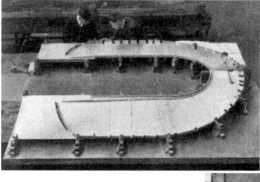

(Above) The tailplane front spar frame nearly completed in the assembly fixture. The inner boom is in position but the outer boon has not been attached. This view shows the cranking of the diaphragm to match the spar sweepback.

(Right) Interior of the rear body of the Bristol Type 167: showing the join of the tailplane with the front spar frame. (Both Aircraft Production)

flying controls of the Brabazon Type I were power-operated, these would be abandoned on the Mk II in favour of spring-tab operation.

In the early days of Brabazon development an electro-hydraulic system of control was chosen, but this was rejected in 1947 in favour of a purely hydraulic scheme of much simpler layout. As alternatives, an electrical system and a second type of hydraulic system were developed simultaneously. To simulate the loads on each of the control surfaces and undercarriage ground rigs were constructed, and for over two years development was in progress with these trial assemblies to produce the most efficient system of hydraulically powered actuators.

During August 1948, after many hours of durability tests on the ground, air-testing was sanctioned and a Brabazon-type hydraulic elevator-operating unit was installed in a Lancaster. Before flight clearance was given for the complete Brabazon system, the elevator unit underwent fifty hours' air-testing. During this period, each of the hydraulic units for the other controls was subjected to a 500-hour actuation and durability test.

The hydraulic system for the Brabazon's power-operated controls was separate from other hydraulic services. It comprised a power supply from twenty engine-driven Lockheed pumps: five on each auxiliary gearbox and four power units, for each aileron, on the rudder and the elevator. Each operating system was divided into two half-systems: the ailerons; four 2,000lb per sq in half-systems with twelve pumps, three to each half-system. The elevators had

two 1,900lb per sq in half-systems with four pumps, and the rudder had two 1,900lb per sq in half-systems with four pumps.

Except for details, all four main units were similar: the movements of the pilot's controls were conveyed by rods to 'follow-up' mechanisms in the appro-

priate hydraulic units, and then on to rotary control valves, which brought jacks into action to move the control surfaces. As the surfaces moved into position the follow-up mechanisms returned the rotary control valves to their central position; thus the pilot's controls and the control surfaces were synchronised. Should a rotary control valve jam, movement of the follow-up mechanism turned a transfer valve, so reducing pressure in the supply line to a bypass valve and, by allowing this valve to open, shortening the supplies from the rotating control valve to the jack. The jack was rendered useless by this automatic operation and the other half-unit was free to operate. A spring device was incorporated in the control system to simulate aerodynamic 'feel'.

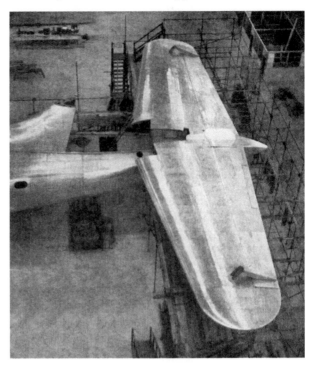

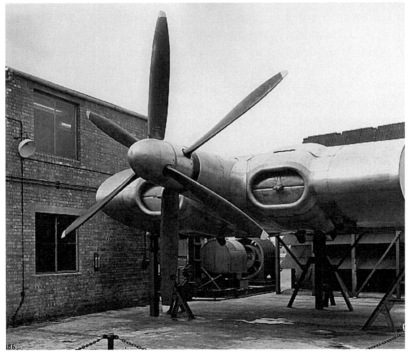

The completed tailplane assembled with the principal component of the aircraft. Owing to their great height, the fin and rudder could not be added until the Type 167 was moved into the new assembly hall. (Aircraft Production)

The third phase testing rig of the engines and aircrew combination. (BAC)

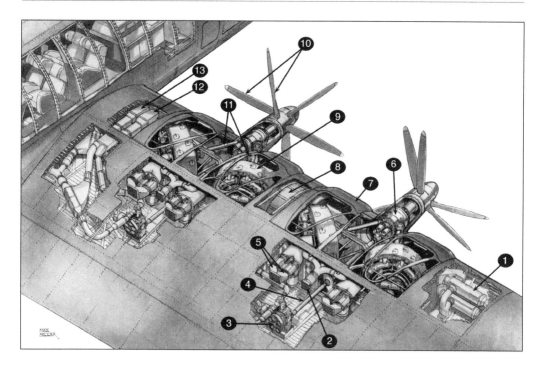

Max Millar's detailed view of the engine area.

1 Anti-icing heaters
2 Main gearbox-oil-cooling radiator
3 Gearbox driving auxiliaries
4 Driveshaft from main gearbox to auxiliary gearbox
5 Engine-oil-cooling radiators
6 Airscrew drive gearbox
7 Engine-cooling air ducts
8 Main oil tank
9 Bristol Centaurus engine
10 Contra-rotating airscrews
11 Tangential drive shafts
12 Cabin blower air intake
13 Cabin cooling air intake

Gust Alleviation

To relieve the wing loads sustained in gusty weather a 'gust alleviator' was considered desirable, and was but one of numerous novelties first developed for the Brabazon. Various suggestions received careful attention before a promising method – a precursor to that fitted to the Mk I – was evolved. It has been estimated that without the alleviator the weight of the Mk I wing would have been increased by about 7,000lb, and that of the Mk II by 13,000lb. In collaboration with the RAE, a Lancaster was fitted experimentally with a Brabazon-type alleviator. The pitot of the alleviator was mounted in the extreme nose of the fuselage and produced a differential pressure on a diaphragm with change of vertical component of wind. The deflection of the diaphragm operated the aileron power-control units through an electrical circuit, which caused the ailerons to be deflected simultaneously in proportion to gust intensity, thus reducing sudden variations in wing loading.

Fire Precautions

The automatic fire-extinguishing system provided protection for: the wing anti-icing heaters; tail anti-icing heaters; cabin-conditioning heaters; each engine and its air intakes; the forward and aft luggage holds; and the electrical distribution centre. There were four banks of eight extinguishers for the engines alone; two in each bank having dual heads for 'second-shot' operation on either engine of a pair. In addition to the fifty automatic units, hand-operated extinguishers were also strategically placed.

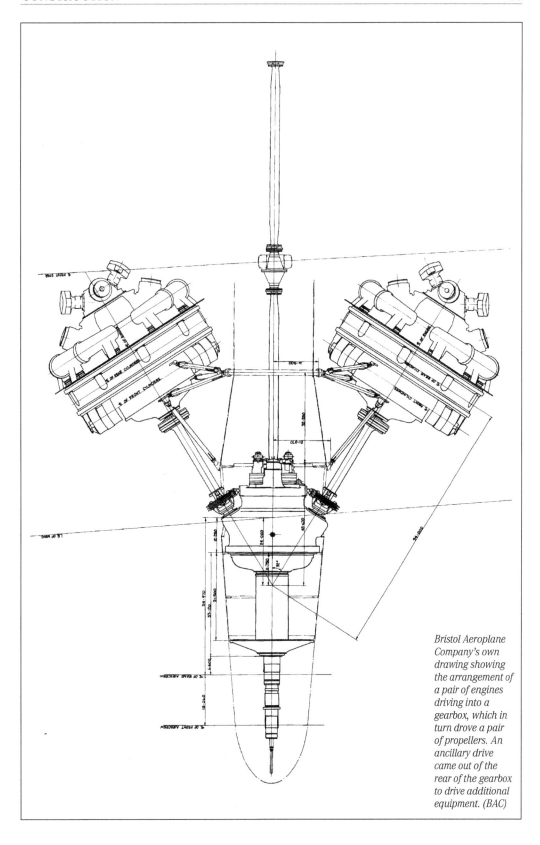

Bristol Aeroplane Company's own drawing showing the arrangement of a pair of engines driving into a gearbox, which in turn drove a pair of propellers. An ancillary drive came out of the rear of the gearbox to drive additional equipment. (BAC)

A vertical view of
four of the installed
Centaurus engines
that clearly shows
their angles to the
aircrew thrust line.
(BAC)

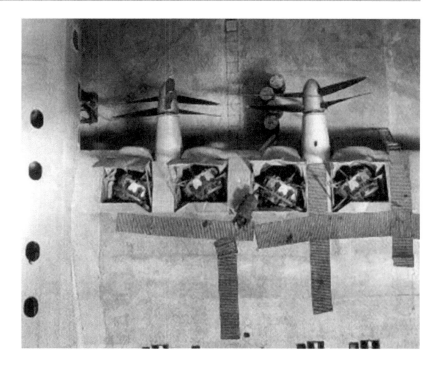

Anti-icing

Thermal anti-icing systems served the mainplanes, tailplane and fin. Two radiation heaters were fitted in each inner wing, just outboard of Nos 1 and 8 engines, and each pair was fed with air from an aperture that derived its supply from the outboard engine air intake. Each aperture had an inlet flap, operated by a hydraulic jack that was electrically controlled from the engine fire panel, and by closing the flaps each heater system could be isolated in the event of fire. Being normally open, the flap ventilated the wing interior in the region of the fuel bags. From the heaters, air was sent along the leading edge to the double skin of the outer wings. The tail anti-icing system, with heaters, was self-contained.

The 'bird-proof' windscreen, comprising several layers of different types of glass and a Perspex panel 0.75in thick, was demisted by hot-air circulation. Although controls for airscrew anti-icing were fitted at the second engineer's station, the wooden airscrews did not have the necessary equipment.

The eight individual Centaurus 20 engines of the Brabazon Type I were housed within the wing and were angularly disposed, one to the other, so that their crankshaft centre lines intersected at a vertex angle of 64°. The crankshafts drove torsion shafts, which in turn drove bevel pinions meshing with bevel wheels carried on the respective airscrew shafts. These latter were nested coaxially, the outer shaft carrying and driving the rear airscrew and the inner shaft similarly serving the front airscrew. Thus, the Brabazon had coaxial airscrews, entirely separate in operation, and not, as was often asserted, a 'contraprop' arrangement (a description which connotes a single airscrew unit of two blade banks).

Before the power-plant installation is described in some detail, it may be noted that the Centaurus 20 was an eighteen-cylinder sleeve-valve, air-cooled unit, generally similar to the Centaurus 18 as installed in the Hawker Sea Fury, but having no built-on reduction gear and being provided with special side-mounting lugs and throttle butterflies oil-heated against icing. Hobson injection carburettors and two-speed superchargers were fitted.

There were three phases of power-plant ground testing. The first concerned the vibration testing of the airscrew shafts and stalks, and employed dummy airscrews and electric motors to simulate the engines. Phase two involved a rig with two Centaurus engines geared together in order to test the gearbox and adjacently mounted engines. For phase three a complete replica of the power plants was made, embodying accessories, and mounted in a section of the wing. Ground tests closely simulating flight were thus made possible.

The power-plant arrangement already outlined was adopted after every alternative had been investigated. Involving, as it did, the use of a single pair of gears (the reduction bevels) for each engine/airscrew drive, the lowest possible transmission loss penalty was incurred. The 'target' mechanical efficiency laid down was inordinately high, one of 99.3 per cent, and the engine division of the Bristol Aeroplane Company had the satisfaction of having proved that the efficiency drop was actually less than that estimated in assessing the target figure.

In order to obviate any adverse effects of primary drive-shaft misalignment, both engines, with their dual-reduction gearbox, were carried by a central box structure. This formed a cantilever projecting forward from the wing spar. The upper and lower surfaces were portions of the wing skin. Each engine was attached to the box structure by means of tubular mountings in the form of

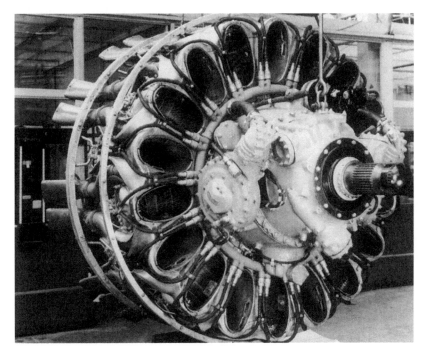

The Bristol Centaurus typified the final development of the air-cooled radial aero-engine in respect to the complexity of its cooling ducting. It was not typical in its incorporation of sleeve-valves, which made for very neat cylinder heads.

twin tripods, which picked up the engine crankcase at their feet and had their apices secured near the top and bottom of the box member by quickly detachable fittings. The tripods took care of all vertical loads and torque reaction, and in order to stabilise the assembly and to look after fore and aft accelerations, two additional tubes were provided, connecting the top and bottom of the engine assembly to a common point towards the front of the box structure.

The exhaust was directed rearwards through shrouded individual pipes, which joined in pairs to the bifurcated exhaust manifold. Two tapering, curved units made up the manifold and carried short discharge elbows at their lower extremities; the shroud was divided into sections, each with a separate cooling air intake and multiple discharge orifices. After leaving the manifold, the exhaust-gas stream was encased in a 'sleeve' of relatively cool air, whereby the heating effect on the wing or undercarriage, such as at take-off, was reduced.

In common with all marks of the Centaurus engine, the cylinders and heads were closely baffled to ensure optimum cooling under all conditions of flight. Surrounding the cylinders was an abbreviated cowl, of approximately cylindrical form, to facilitate spark-plug inspection. This was provided with small access panels immediately over the cylinder heads. The rear end of the cowl assembly was in flexible contact with a diaphragm surrounding the engine and dividing the engine cell into two zones; the forward zone was in full ram-air pressure, which was not only used for engine cooling but also fed the main engine air intakes. In addition, a duct conveyed air from this region to the oil coolers behind the front spar.

After cooling the engine, the warm air in the region behind the diaphragm was discharged through controllable cooling flaps in the upper and lower wing skins. Under normal flight conditions, the upper flap remained closed, thus maintaining drag at an absolute minimum, while the lower flap was adjustable in order to control the degree of cooling.

Power from each engine was transmitted through a tubular driveshaft to the dual-reduction gear. At the rear end the driveshaft was bolted to the engine crankshaft flange through a flexible coupling. This consisted of a light alloy ring carrying a number of rubber trunnions. The flexibility of the trunnions was sufficient to accommodate any slight deviation from true alignment that might be encountered. At its forward end the shaft was united to the input flange of the dual-reduction gear by a universal joint, equipped with non-metallic pre-loaded bearings.

Means were provided for measuring the engine torque by electrically determining the degree of torsion

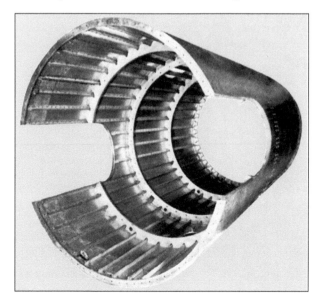

The airscrew stalk, in which the co-axial airscrew drive was housed. This was a tapered monocoque structure that closely followed conventional fuselage-building practice. (Aircraft Production)

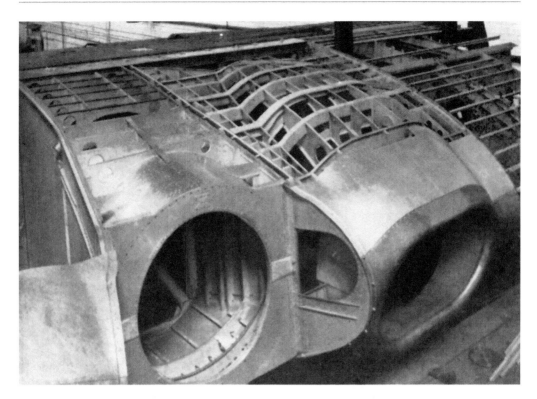

in the primary driveshaft tube. For this purpose, two toothed inductor rings encircled the universal joint; one of these was carried directly by the forward end of the driveshaft tube and the other was supported on a spider member, deriving its location from the engine end of the driveshaft. Associated with the inductor rings was a double 'generator', in which electrical impulses were induced. Phase differences between the impulses of the two portions of the generator provided an indication of true engine torque.

A portion of the leading edge structure, showing the airscrew shaft 'bay' on the left and beyond it, an air intake and one of the top-surface engine-access door structures. (Aircraft Production)

Two complete and independent reduction gears were incorporated in the magnesium-alloy casing, with means of driving the aircraft accessories and a simple system of lubrication and cooling, both of which functioned whether either or both of the engines were running. The reduction ratio was 0.400.

The right-hand power input shaft carried at its forward extremity a straight-tooth bevel pinion, the teeth of which meshed with the ground teeth of an internal bevel gear. This gear was serrated to the large-diameter tubular shaft carried on ball and roller bearings in the magnesium casing, which drove the rear of the coaxial airscrews. The shaft was made up of three sections, flange-bolted together. Nesting within it, and running in a series of ball and roller bearings, was the inner airscrew shaft, carrying at its forward extremity the forward airscrew and at its rear extremity the main driving bevel wheel. In mesh with the teeth of this wheel were the teeth of the left-hand input bevel pinion.

Notwithstanding the high efficiency of the gear trains, considerable heat was generated at the actual tooth-contact point. To maintain a satisfactory temperature level, oil jets impinged upon the tooth flanks as they came out of mesh; oil draining away was cooled and recirculated.

Two views of the precise scale model of the building and aircraft components used by Bristol engineers to experiment and check that the partially completed aircraft could be moved out of the original assembly building. (Both Aircraft Production)

The Move

Halfway through the construction of the first aircraft the main components had to be moved from the original building to the new assembly hall. In order to proceed with the project in the shortest possible time an existing flight shed at Filton was used while the large assembly hall, specially designed for the manufacture of subsequent aircraft of this type, was under construction.

The area available in the original flight shed measured 280ft by 120ft and, by the use of much ingenuity and forethought, the fixtures for the main component of the aircraft – which consisted of fuselage, centre section and tailplane – with the fixtures for the outer mainplanes and the fin, were all accommodated.

The manner in which the accommodation was made meant that the outer-wing and fin-assembly fixtures were grouped together in the south end of the shed. The position of each fixture had been planned to avoid an obstruction during the removal of any component after construction.

The main span of the building was interrupted midway along its length by a support stanchion, which reduced the space available for removal to approximately 140ft. The only logical way to remove the aircraft from the shed, therefore, was to turn it through an angle of 90° from a static point and draw the span of the inner wing through the maximum opening between the centre support and the north wall of the shed. The major problem, however, was to fix upon a point that would give clearance to the aircraft structure as it turned through 90° and to bring it into a position for withdrawal tailplane-first, without the starboard end of the inner wing fouling the centre main support. Due to the 177ft fuselage length, the clearances for the port tailplane tip and the nose of the aircraft were limited at two critical points. Careful calculation and layout work aided by the scale models were necessary in order to decide on the most satisfactory method of removal.

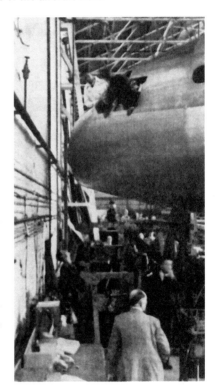

In its final form, the removal scheme was based upon the use of a turntable made to support the starboard undercarriage wheels. The aircraft was swivelled until the first critical position was reached, at a point where the port tailplane tip was nearest the north, inner wall. Here, the maximum clearance (after removal of a shop-heating unit on the wall) was only 28.5in. The second critical position occurred where the nose came into very close proximity with the east wall. Here, a maximum clearance of 15in was available, with the addition of the offset eccentricity provided on the turntable.

On Saturday 4 October 1947 the principal component, consisting of the fuselage, inner wings and tailplane, was successfully removed from the flight shed in which it had been assembled and transported to the new assembly hall, one bay of which had been made ready for its reception. A beginning was made at 7.30 a.m. and the operation was completed, with the aircraft in the new assembly hall, by 1.30 p.m.

From model to reality! Calculated clearances work out: the nose approaches within 15in of the east wall as the main component is turned into position for withdrawal.

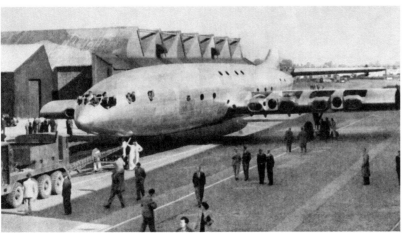

The main component after being removed from the original flight shed in which it was built. (Both Aircraft Production)

Some idea of the restricted space may be gathered from the fact that it was necessary to remove the nose cap of the fuselage so that the forward end would clear the east wall of the shed.

In order to reduce to the minimum the possibility of errors through misunderstanding, the work of moving the aircraft was restricted to five people only: the foreman in charge, the tractor driver, two nosewheel steering-arm operators and the brake operator inside the aircraft. Signals to the driver of the tractor were given visually by the foreman in charge, who was in constant communication with the brake operator. All signals were determined in advance and for each move the foreman was in a position that gave a clear view of the critical clearance point. After each move the aircraft brakes were applied as a safety precaution. The planned track of the main wheels and nosewheel was painted in yellow on the floor of the flight shed, as was the path to be followed by the tractors used to swing the aircraft on the turntable and later to tow it to the final assembly hall.

The complete route taken by the aircraft during the transfer from assembly shed to the final assembly hall. The new runway, which with the assembly hall entailed very heavy civil engineering operations, is shown in the top part of the plan. It is connected by a link road, over a railway level crossing, with the assembly hall.

At this stage of assembly the aircraft component weighed approximately 38 tons and the tractive effort needed was calculated as being slightly below 10 per cent of the weight, or just less than 4 tons. A David Brown tractor was used for the operations inside the shed.

In the first movement, the aircraft was drawn back on its centre line through the distance of 9ft necessary to bring it into position for the turn, with the starboard main undercarriage wheels on the turntable. A cable was attached to each of the towing lugs on the port and starboard main undercarriage legs, and the combined cables connected to a winch on the tractor, which could exert an effort of 4.91 tons. In this way an even and consistent pull was applied, which was essential to the success of the operation.

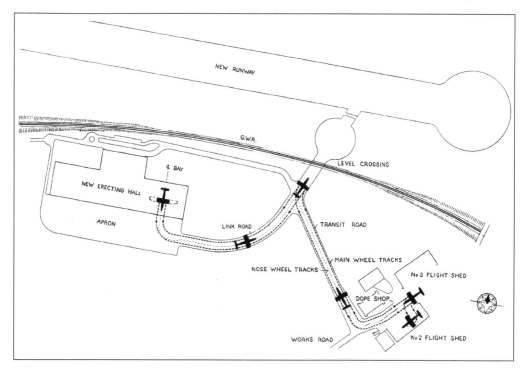

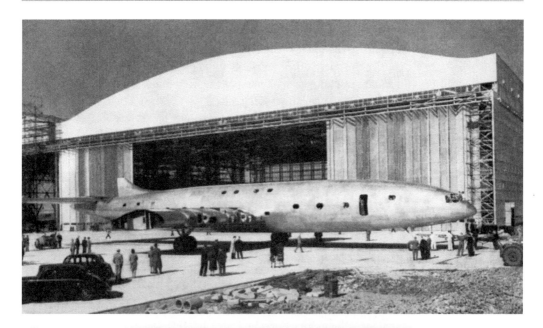

The main component arrives on the concrete apron outside the new, incomplete assembly hall.

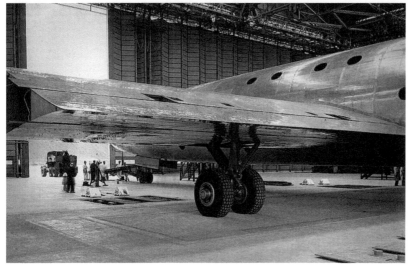

The main component of the Bristol Type 167 is ensconced in the new assembly hall. (Aircraft Production)

Owing to the extremely small clearance between the nose and the east wall of the flight shed on the turn, it was imperative that there should be no deviation from the straight line as the aircraft was drawn backwards.

For the 90° turn the two towing cables were detached from the undercarriage legs and the tractor winch cable was secured to the port leg only. The starboard wheel was securely fastened to the turntable in wheel chocks by clamps.

After some manoeuvring, the aircraft was ready for extraction from the flight shed. Starting from a point aft and immediately in line with the starboard undercarriage leg, the tractor was driven along a track of 109ft mean radius marked out on the roadway outside the flight shed. This had the effect of swinging the aircraft round a point outside the outboard end of the port

inner wing until its nose was pointing south along the works road. During the movements in the flight shed, the maximum roof clearance – above the highest point of the dorsal fin – was not more than 20in.

An Albion tractor was connected to the nose undercarriage leg for towing the aircraft along specially reinforced wheel tracks to the assembly hall. So it could be moved carefully to the new assembly hall it was steered along the painted track until there were no critical clearances. Once in, the remainder of the construction could take place and the equipment could be installed.

The Official Naming Ceremony

It seems strange, but the official naming and roll-out took place with much pomp and ceremony roughly two years before the first flight of the Brabazon. The ceremony had been planned to be conducted by John Charles Wilmot, 1st Baron Wilmot of Selmeston PC, the Minister of Supply, but changes in government the day before forced rapid rearrangement of the programme with Air Marshal Sir William Alec Coryton, KBE, CB, MBO, DFC, Controller of Supplies (Air) of the Ministry of Supply conducting events on 8 October 1947. Alongside him on the dais was Charles Gill, the Lord Mayor of Bristol, Lord Brabazon of Tara and Mr William R. Verdon Smith of Bristol Aeroplane Company.

In his speech, Sir Alec made note that 118 years earlier, to the day, Stephenson's locomotive *Rocket* made its historic run on the Liverpool–Manchester railway. There were many sceptics then, and there were many now, but he welcomed the spirit of adventure which had animated the Bristol Type 167 project right from its start during the latter part of the war. Fortunately, there had always been men of imagination and foresight, he said, and he wished to pay tribute to one of those: Lord Brabazon of Tara, whose committee had drawn up the requirements. Much work still remained to be done before the machine could fly, but he based his faith in the aircraft and on the skill and determination of those who were playing such an important part in the fulfilment of this great enterprise. He then formally named the first Type 167 the Brabazon.

Thousands of Bristol employees witnessed the ceremony and as the machine was moved into the new assembly hall they swarmed around it, admiring the work done so far while invited guests, who included representatives of government, the Ministry of Supply, the Ministry of Civil Aviation, BOAC and the Society of British Aircraft Constructors, enjoyed an excellent lunch.

Charles Gill, the Lord Mayor of Bristol, expressed great pride in the Bristol Aeroplane Company, for as much as Filton was not in Bristol, many Bristolians worked there. The building of the Brabazon was proof, he continued, that England was not finished, as some people thought, and that she was still capable of leading the world.

The man who was supposed to name the Brabazon: John Charles Wilmot, 1st Baron Wilmot of Selmeston PC (2 April 1893–22 July 1964). A British Labour Party politician, he served under Clement Attlee as Minister of Aircraft Production from 1945–46 and as Minister of Supply from 1945–47.

After the ceremony, Bristol Aeroplane Company revealed more about the airframe to the press: under a pressure difference on 5.5lb per sq in the fuselage would 'grow' in length by about 0.5in and in diameter by an expected 0.25in; to cover the fuselage and wings, no less than 30,000sq ft of sheet metal was required; the structure, weighing some 91,000lb, took up 32 per cent of the all-up weight; the engines, weighing 38,000lb in all, took up 13.33 per cent; fuel and oil took up 33.34 per cent, weighing 95,000lb. This left, said the Bristol Company, a net payload of 24,000lb, just 8.42 per cent of the all-up weight.

On 8 October 1947 a naming ceremony took place when Air Marshal Sir Alec Coryton officially named the Bristol Type 167 the Brabazon.

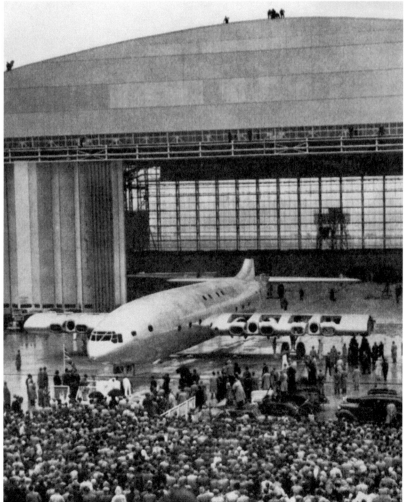

Popular myth has it that the aircraft was named by Lord Brabazon of Tara, in fact it was named after him. Air Chief Marshal Sir William Alec Coryton KCB, KBE, MVO, DFC, RAF (16 February 1895–20 October 1981) actually named it. Commonly known as Alec Coryton, he was a senior RAF commander in the Second World War. (Aircraft Production)

Accessory Drives

There were two subsidiary gear trains in the gearbox. The first of these picked up the drive from the outer airscrew shaft and conveyed this through idler gears and a shaft to a free-wheel unit and from there to the aircraft accessory driveshaft. The second train picked up a drive from the inner airscrew shaft and similarly conveyed this to the same accessory driveshaft; this shaft carried a small gear which drove the main oil-pressure and scavenge pumps. If either engine was closed down, the section of the free-wheel unit associated with the drove from that engine commenced to slip, or 'free-wheel', the other engine carrying on with the drive. With both engines running, notwithstanding that their speeds were nominally synchronised, there would inevitably be minor speed fluctuations between the two drives to the free-wheel unit.

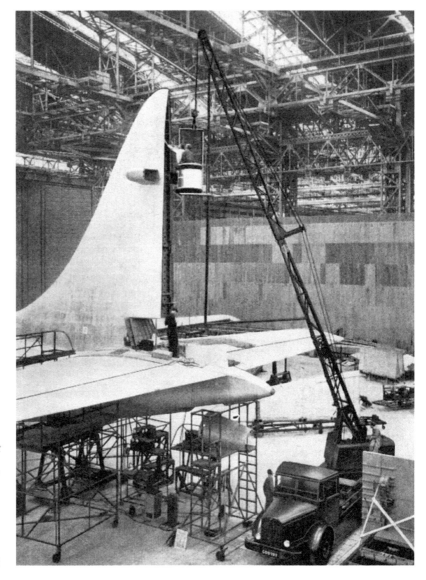

Such was the scale of the design, fitment of the fin and rudder could only be achieved by using a mobile crane with a boom extension. The 'lumps' on the fin were for rudder mass-balances. (Aircraft Production)

In order to avoid any possibility of resulting shock-loading, the drive ratios had been carefully selected so that under synchronised conditions the entire accessory load was carried by the right-hand engine. Meanwhile, that portion of the free-wheel unit associated with the left-hand engine 'free-wheeled' at a very low speed difference.

The ancillaries serving the coaxial airscrews were located on the rear cover of the dual-reduction gear unit. These consisted of the airscrew controller units and the synchronising alternators. Drives for these units were tapped off the gear trains that drove the free-wheel units.

Lubrication of the working parts was by a supply of cool oil pumped to vital points by a gear-type pressure pump; this pump also supplied the oil necessary for hydraulic airscrew operation, a filter being interposed in the circuit to exclude any small particles of matter from the constant speed-control mechanism.

Feathering

During single-engine operation, the non-operative airscrew was, of course, feathered. If the front airscrew only was feathered, the aerodynamic forces acting on the blades did not produce any airscrew fuming moment. In the case of a feathered rear airscrew, however, the blade angle for minimum drag was such that a reverse airscrew-rotating moment was produced. Since this was undesirable, means were provided inside the dual-reduction gear to

Bristol picture T.167/851, the Brabazon is seen with outer wings, engines and propellers fitted. The forward-opening engine covers are particularly evident. In the foreground is the Lancaster used for gust trials. (BAC)

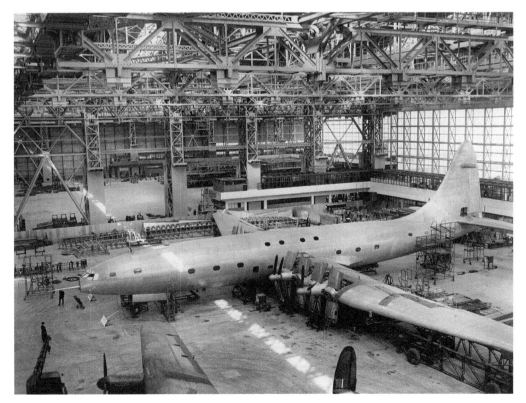

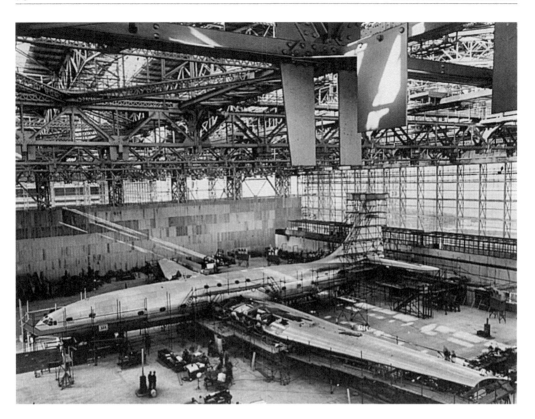

The first Brabazon inside the new assembly building, which was still in the throes of completion. With scaffolding around the aircraft as well, it's hard to tell where one starts and the other finishes! (BAC)

prevent it. Carried on the forward face of the internal bevel gear was a large ratchet wheel. Three pawl units equally spaced round this wheel, but attached to the front cover of the gearbox, were brought into action automatically by the airscrew-feathering oil supply. The pawls 'clicked' over the ratchet wheel teeth while the latter was rotating in a forward direction with the rear airscrew. As the feathering process was completed, the airscrew slowed down and came to a standstill before the reverse torque built up. At this point the teeth of the ratchet wheel were brought into abutment with the pawls, thus preventing reverse rotation. In normal operation an arrangement of springs completely retracted each pawl. As a means of precluding excessive torques in the reverse direction – that is, in the event of a backfire – the ratchet wheel mounting incorporated a high-torque slipping clutch.

Three entirely independent oil systems supplied the left-hand and right-hand engines and the dual-reduction gear respectively, and each consisted of an oil cooler and a service oil tank. As already intimated, air to the oil coolers was ducted from the forward portion of each engine cell; the ducts ran straight to the twin oil coolers which discharged their air through variable-area shutters into the main wing space. The reduction-gear cooler was jointly fed by small ducts from both the main cooler ducts. This also discharged into the wing space. Air outlets from the wing space were provided through the rear spar and upper wing skin, near the trailing edge. Oil consumption was made good by maintaining a constant level in the service tanks, make-up oil being supplied from a common pressurised storage tank within the wing.

Complete fire-indicating and fire-extinguishing equipment was built into the power plant. At critical points on each engine, and attached to the fireproof walls of the engine cell, were a series of flame-detecting switches, electrically connected to fire-warning indicators at the first engineer's station. Should fire break out, the engineer would immediately be warned. He would first close the cooling-air shutters, turn off fuel and oil, close down the engine, feather the airscrew and then put the fire-extinguisher system into operation. The system consisted of a series of rings encircling the forward and aft portions of the engine; through these a methyl bromide fire-extinguishing medium was forced and, being sprayed from numerous small holes in the rings, would completely smother any fire. In addition, supplies of methyl bromide were taken to the exhaust manifold and also to the engine air intakes, thus ensuring that combustion within the engine ceased immediately.

In order to prevent any possibility of flames from an engine cell penetrating to the wing space behind the spar, shutters were provided at the entry to the oil-cooler air ducts.

The aircraft services were operated both electrically and hydraulically, and were maintained by pumps and alternators driven by the main engines. These were grouped around the accessory gearbox, which, in turn, was securely bolted to the 'floor' of the wing space between the two spars. Lubrication of this gearbox was self-contained, a sump of moderate capacity and a pump being provided.

Artwork from the brochure that details the propeller hub. (BAC)

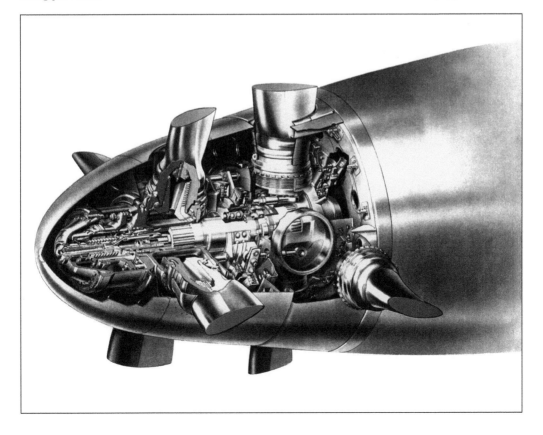

The drive to the gearbox was by means of high-speed shafts connecting with the accessory drive output shaft at the dual-reduction gear. This shaft was in two main sections, each about 5ft 6in long, united by a short intermediate shaft. At each end of both sections of the shaft were flexible joints.

Airscrews

The eight Rotol wooden airscrews were special three-bladed, hydraulic, constant-speed, feathering and braking units of 16ft diameter. All were similar except that the operating cylinder for the front unit was not made in annular form. Engine/airscrew control embraced synchronous control of the engines in addition to the control of airscrew pitch for constant speeding, feathering and braking functions. The system was based on the selection of one engine as a 'master' – the remaining engines being 'slaved' – and subject to automatic continuous correction to the governing RPM of the master. Left-hand engines of each pair were arranged as masters, but only one unit was employed as such at any one time.

The rotors of the corrector motors were joined by worm gears and mechanical linkage to the constant-speed mechanisms within the controller unit. One

winding of each corrector was taken to its own engine's alternator, the other winding being connected to the alternator of the master engine. Each corrector was, in fact, an electric differential, which, when all engines were in phase, would not turn; but when a speed difference did exist it would rotate at a speed proportional to the difference, and in a direction determined by whether its engine was over- or under-speeding relative to the master.

The braking operation of the airscrews was not completed until the undercarriage wheels were settled on the ground, with the forward speed of the aircraft at no more than 120mph. Immediately prior to touchdown the captain would set the throttle levers to 'SR' (slow-running ahead). As the aircraft touched down he operated the master switch and unlocked the airscrew-reversing lock, then moved the throttle levers through to minimum braking (slow-running reverse)

The first engineer's power panels.

The engineer's station. (Both BAC)

position. This operated a switch that energised a braking solenoid in the air-screw system. Next, a pause of a few seconds was allowed before he opened up the engines to give the required degree of braking.

A weight-sensitive switch on the port main undercarriage leg allowed the circuit to be alive only when the port wheel was on the ground. This weight-sensitive switch also indicated, by a lamp, to the captain that the aircraft was airborne.

Standard Instrumentation

The first aircraft was fitted with a whole range of what could be termed 'standard instrumentation' – apart from all the flight-test equipment. Working from the nose backwards:

The pilots' station: dashboard panel, port (captain): radio altimeter limit indicating lamps (white light = above height; green light = desired height; red light = below height); radio altimeter (gave true height); airspeed indicator (operated by pitot protruding from port side of fuselage); undercarriage warning lamp (red) (light went on and buzzer sounded when engines throttled back whilst undercarriage was up); button for testing undercarriage warning system; oxygen bayonet fitting.

Dashboard instrument flying panel (two installed): altimeter (pressurised 0–45,000ft); artificial-horizon indicator; air-speed indicator (50–350 knots, operated from pitot in nose); rate-of-climb indicator (registers climb or descent up to 2,000ft per min); G.3 gyro compass, turn-and-slip indicator.

Dashboard centre panel: Flap-position indicator; time-of-flight clock, D/F visual indicator; air thermometer; barometer (absolute pressure); control panel (GM compass).

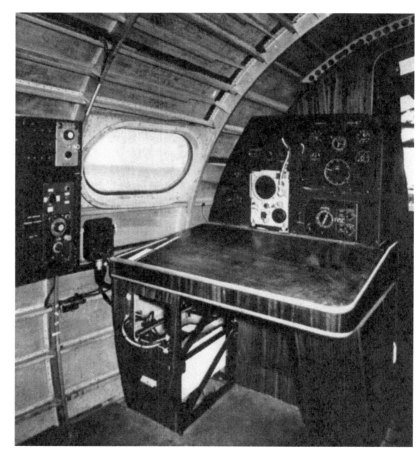

The navigator's station. Situated aft of the captain's seat, the navigator faced forward. He had a chart table, drawers and cupboards for instruments and books, a switch for the Gee set, air-mileage indicator, repeater unit for the air-position indicator, airspeed indicator, sensitive altimeter, twenty-four-hour clock, air thermometer, radio altimeter, compass master indicator switch for API, transmission, API, signal pistol and inverted P.12 magnetic compass. (BAC)

Dashboard starboard panel (co-pilot): oxygen bayonet fitting; cabin pressure-height indicator (0–30,000ft).

Other controls and instruments (either at top or bottom of dashboard): control-surface-locks warning lamp; ice-detector warning lamp; voice and range filter; intercommunication station box for both the captain and co-pilot; undercarriage buzzer; rudder pedals adjustment; controls-locking handle.

On the port side of the cockpit for the captain were: cupboard; dimmer switch for side-panel lamps; dimmer switch for pedestal lamps; altitude limit switch (50–300ft); inboard and outboard pressure-head heating switches; windscreen de-icing switch; windscreen-wiper control and switch; lighting switch; dimmer switch for the dashboard ultraviolet lamps; dimmer switch for the dashboard red lamps; intercom change-over switch; autopilot controller; VHF controller; beam-approach remote control; autopilot switch; indicator unit; autopilot on/off switch; nosewheel steering control; intercom socket.

On the starboard side for the co-pilot: intercom socket; autopilot controller; identification-lamps signalling switch; gust-detector-head heating switch; taxiing lamps switches; navigation lamps switch; windscreen-wiper switch; windscreen-wiper control; lighting switch; dimmer switch for roof-panel lamps; dimmer switch for side-panel lamps; dimmer switch for dashboard red lamps; dimmer switch for dashboard ultraviolet lamps; small cupboard; stowing bracket.

Just some of the flight-test equipment installed inside the Brabazon Type I, along with the photographic recording equipment. (BAC)

The radio operator's station. This was on the port side of the flight deck to the rear of the navigator's station. The radio operator sat facing aft. Little equipment was needed for early flight trials. (BAC)

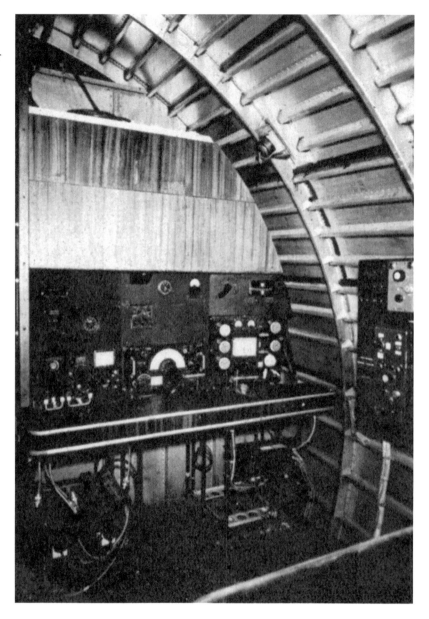

Between the two pilots the centre pedestal contained: flap selector lever; No 1 and No 2 throttle lever (yellow); No 3 and No 4 throttle lever (yellow); No 5 and No 6 throttle lever (green); No 7 and No 8 throttle lever (green); throttle-locking lever; airscrew-reverse lock; airscrew reverse master switch; aileron, elevator and rudder-trimming handwheels and indicators; landing-lamp switches; master ignition switch; four boost gauges.

Control columns and subsidiary controls on the captain's and co-pilot's control columns: press-to-transmit button; elevator inboard tab switch; autopilot cut-out button; master control switch; controls-locking handle; rudder-pedals adjustment handle; four red control-surfaces-locking indicator lamps; two sets of rudder and brake pedals.

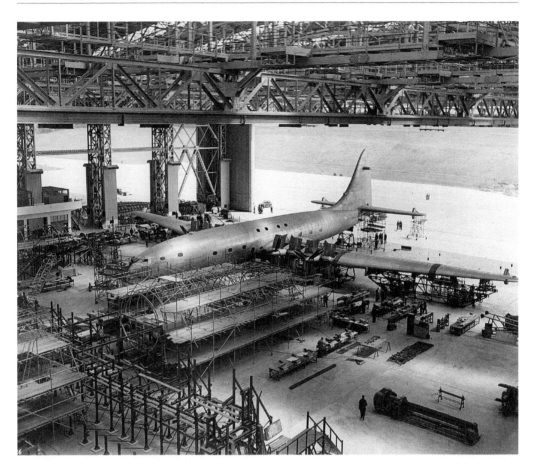

The roof panel: undercarriage position indicator; undercarriage master switch; wheel-brake indicator lamps; brakes push button; aileron-raising and lowering buttons; aileron position indicators; aileron gust-relief switch; aileron gust-relief indicator lamp (a white light, which showed when a gust was encountered and immediately went out when the appropriate relief push button was operated to correct position of ailerons); rudder position indicator; elevator position indicator; undercarriage emergency retraction switch (in case of a baulked take-off or possible ground collision this enabled the pilots to raise the undercarriage without reference to the engineers in the compartment aft. The operation was electro-hydraulic).

The first aircraft undergoes work on its engines whilst the second aircraft starts to take shape towards the foreground. (BAC)

The two engineers were positioned on the starboard side of the night deck, aft of the pilots' station. Both had swivel seats. The first engineer's controls were forward and outboard, and those of the second engineer outboard and aft:

The first engineer: When facing forward the first engineer had in front of him the port and starboard power panels and airscrew-synchronising panel. Above the power panels was the engine fire panel, which also included flight instruments that were visible to both engineers. Below the power panel, but on the table, were the throttle controls.

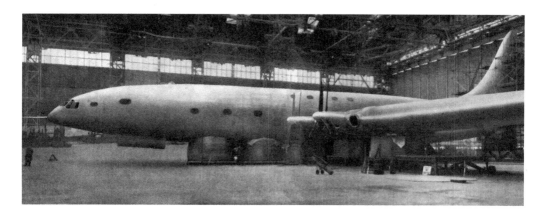

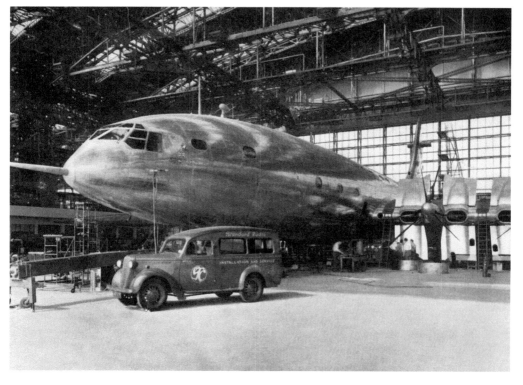

The undercarriage retraction tests used air bags instead of conventional aircraft jacks to support the aircraft. Much of the radio equipment came from Standard Radio, as seen in this publicity picture. (Both BAC)

When facing outboard the first engineer had in front of him, from top to bottom: the port and starboard oil-system panels; four engine-temperature panels; four dual-reduction gearbox and airscrew-control panels. Below the latter, but on the table, were airscrew and speed controls and, to the right of these, the undercarriage control panel.

The second engineer: When facing outboard the second engineer had in front of him the following panels: fuel; anti-icing; power-operated controls; intercom; brakes and oxygen; humidity; air heaters and flow control; cabin-pressure control. His table incorporated the flap-control panel and control-surfaces locking lamp.

When facing aft the second engineer had in front of him the following panels: (at top) a general fire panel; (at centre) electrical, port and starboard

alternators and forward and aft DC; (at bottom) flight instruments supply, crew-station lights and instructions for electrical operations; (on the floor) a hydraulic hand pump for control-surfaces locking.

Flight-test Instrumentation

Every hour the Brabazon Type I was in the air yielded its measure of technical experience, and with such a complexity of systems and services involved it was not surprising to discover that more than half the fuselage was occupied by approximately 1,000 instrument dials (including a number of oscillographs, many made at the Royal Aircraft Establishment, Farnborough). All readings were recorded photographically or plotted automatically for analysis in Bristol Aeroplane Company's flight-research laboratory; thus valuable time was saved in the checking of performance jointly with the Aeroplane and Armament Experimental Establishment, Boscombe Down, in completing and refining design, and in accelerating production of the Mk II aircraft.

The test instruments used were mainly of synchronous electrical type, each with a transmitter containing an element sensitive to the quantity to be measured and with means of electrically repeating the indications of these elements to dials in the cabin. In order that each group of dials would give a complete picture of some function or aspect of performance without the need for cross-reference, the dials were grouped in twelve panels, relating to the following:

1 Aircraft performance (speed, height, rate of climb, etc.)
2 Performance of essential services (hydraulic systems – excluding the power-operated flying controls – and the fundamentals of the electrical system)
3 Operation of powered flying controls
4 Engine cooling
5 Engine temperatures

Very few pictures show the two Brabazons together; here G-AGPW is seen in front of the incomplete Mk II G-AIML. (BAC)

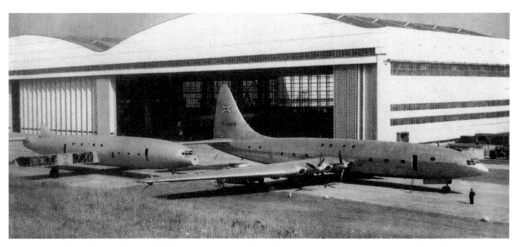

6 Engine oil temperatures
7 Airscrews
8 Oil temperatures in the hydraulic systems
9 Output etc. of the electricity-generating system
10 Pressurisation
11 Anti-icing (including external skin temperatures)
12 Aerodynamic pressures and flows

Two types of camera were used. For panels where readings remained approximately constant with a given flight condition, the periodicity of photographic record varied from one picture every ten minutes to one every other second and a negative size of 5in by 5in – which was sufficient to cover 170 dials. Where the rate of indication change was greater – that was, in the aircraft's response to control movements – the photographic periodicity could be as high as four per second. This requirement was met by specially built 35mm cinematograph cameras. The twelve cameras were controlled from a master station on the flight deck, where the chief test engineer was stationed, but observers could immediately override the master control had they noticed any trend or condition which, in their opinion, should have been recorded. Normally, however, all cameras operated simultaneously to obtain a full record of performance under selected conditions.

Bristol image T.167/852 shows the first aircraft nearing completion in the assembly hall. (BAC)

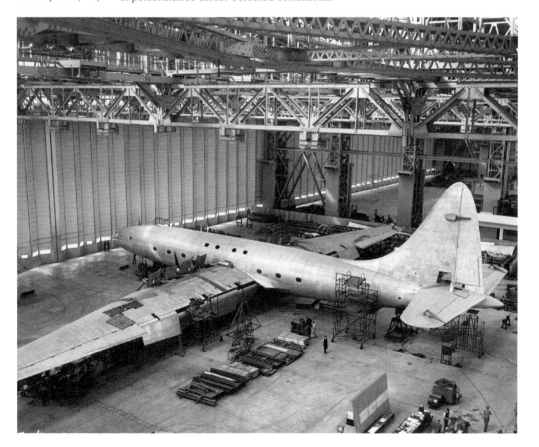

Two mirror galvanometer oscillographs, each capable of showing fifteen quantities simultaneously, recorded low-frequency vibrations of up to sixty cycles per second (such as those caused by aerodynamic forces) and steady strains in the structure. High-frequency vibrations up to 1,000 cycles per second (e.g. those caused by engine forces) were recorded by cathode-ray oscillographs reading from four stations at one time.

A continuous watch on the operation of various emergency devices was maintained by three 'lamp recorders', each containing 120 lamps. Should any lamp light up, it would produce a line on a slow-moving film, thus recording the timing and duration of the associated operation.

Special test requirements were inevitable during the Brabazon trials, and to meet them various portable and self-recording instruments were provided. In conjunction with two double-beam, cathode-ray oscillographs, they enabled any flight phenomena to be observed.

The duration of the ground tests which preceded the first flight (during which the instrumentation was being adjusted) is readily accounted for if it is borne in mind that up to 100 hours of laboratory work were entailed for every hour of flight testing. The reward for the elaborate instrumentation described is a mass of unique technical records of immense significance.

Radio and Intercommunication

For early flight trials the Brabazon Type I had VHF and MF W/T communications equipment, Marconi automatic direction-finding, Gee and a radio altimeter. All flight-crew stations had facilities for any three receivers and any two transmitters, together with intercom.

There were three separate intercom channels, with no fewer than forty-nine points; any two or all three channels could be mixed, or, as for the first flight, all three could be fed together to the flight deck. Availability of three channels means that the flight observers could conduct three separate tests simultaneously without cross-talk on one channel and without interfering with conversations on the other two or the flight deck. The chief observer was stationed at the navigator's position and controlled channel mixing and selection.

With the aircraft complete, it was now time to start testing.

4

COMPLETION AND FLIGHT

Dr Archibald Edward Russell CBE, DSc, FRAeS, FIAS, who became chief designer during the Bristol Type 167 project, reported that the finished structure of the first aircraft weighed '... within a few pounds of the estimate'; without a doubt it is fair to describe the Bristol Type 167 as being a major structural success. One firm that shared that success was Folland, which not only detailed and constructed all the control surfaces and split flaps, but also designed and built the huge transport trolleys and slinging gear for offering up or removing the outer wings, landing gear, flaps and control surfaces.

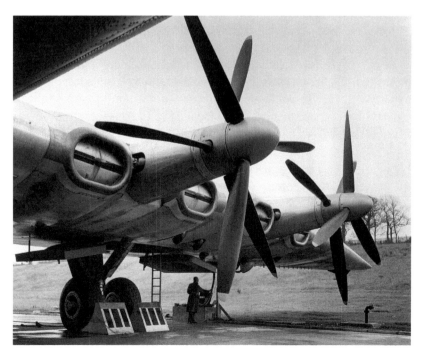

The huge aircraft was fuelled from one of the aircraft servicing points on the apron at Filton. (BAC)

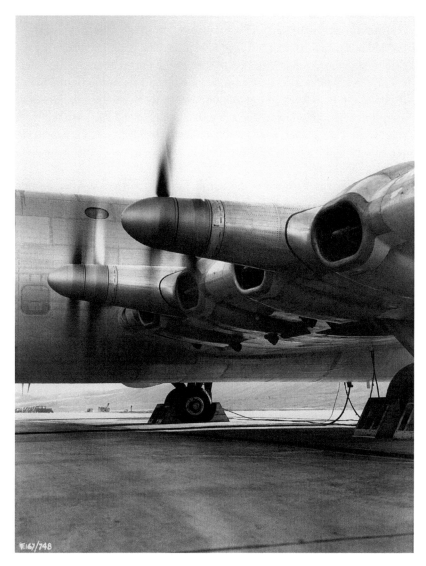

The huge aircraft was fuelled from one of the aircraft-servicing points on the apron at Filton. (BAC)

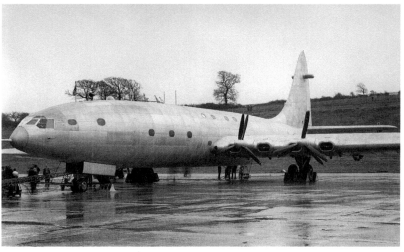

With ground power connected, the aircraft is prepared for another series of ground runs. (BAC)

Arthur John 'Bill' Pegg, who had been an Aircraft and Armament Experimental Establishment test pilot at Martlesham Heath before joining the Bristol Aeroplane Company, had lately been in the United States getting some time in on very large aircraft. These included (courtesy of the United States Air Force) the B-36, then in production with thirty-five delivered. The B-36 was within a few feet of being the same size in length and span as the Bristol Type 167, so it would have been good experience. Everyone eagerly looked forward to getting the wheels off the ground in 'a week or two', after completion of some ground tests.

Brabazon prototype G-AGPW did not fly for eight further months, despite what appeared to be ceaseless hustle. Increasingly, the newsreels and press began to question the validity of the project. A good example is British Pathé News, the newsreel organisation which said in a film released in August 1949:

> ... by the time Bill Pegg takes her up, she will have cost the British taxpayer all but six million pounds. The first Brabazon is a prototype only – a flying laboratory, never intended to go into service. But clouding her sense of triumph at her near completion are publicly voiced doubts about her ability to compete commercially with smaller, less costly airliners. Her final engine tests are made with her future still a question-mark.

The 'smaller, less costly airliner' comment was possibly a reference to the de Havilland Comet that had just flown, for the first time, a month earlier – and without subsidy from the taxpayer. The commentator went on: '... her thousand foot hangar adds nearly three million pounds to the cost of the Brabazon venture which, with another two and a quarter million spent on the construction of a special runway, puts the total bill to nearly twelve million.'

Pathé News also queried if there was a market for the Brabazon: '... the unknown factor in Brabazon's future is the demand for air travel by the time she joins the transatlantic traffic. To be economical, she may be restricted to one or two crossings per week, so losing her pull against more frequent services.' Bob Danvers-Walker, the Pathé News commentator, signed off his piece with: 'Her chief shareholders, the taxpayers, wish her luck!'

Arthur John 'Bill' Pegg (1906–1978) on the flight deck and alongside the aircraft with his Bristol 401 car.

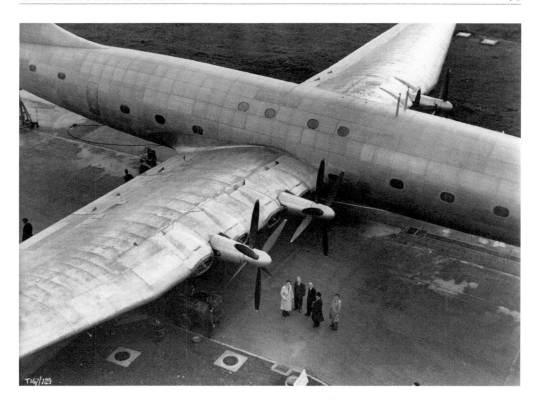

Mentions in Parliament

There were ongoing discussions about the aircraft in both the House
of Commons and the House of Lords. For example, on 21 January 1948
Conservative back-bencher Sir Luke William Burke Teeling (5 February 1903–
26 October 1975) asked the Parliamentary Secretary to the Ministry of Civil
Aviation '... whether he will give a list of the airports where the Brabazon will
be able to land in parts of the world served by British airlines; and how many
of these are within reasonable distance of each other in case of one of them
being unserviceable'.

George Samuel Lindgren JP, DL (11 November 1900–8 September 1971)
replied:

*Two somewhat
unusual views taken
from the roof of
the main hangar
that show both the
chord and depth
of the wing of the
Brabazon ...*

The Brabazon I was designed for the North Atlantic route. It is anticipated
that a re-designed undercarriage, to be fitted to the operational aircraft, will
allow of the use of aerodromes on the route as developed for contemporary
types. Pending the outcome of a series of engineering experiments, I am
unable to give more definite information.

Mr Teeling: While I thank the Hon. Gentleman for that reply, may I ask if
he will make it quite clear, because so many people seem to think that the
Brabazon is going to be used elsewhere?
Mr Lindgren: It is designed for the North Atlantic. Whether or not it will be used
on other routes will depend on the characteristics of the aircraft when it flies.

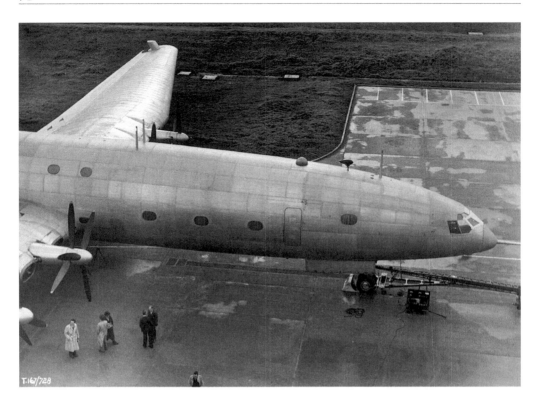

... along with various intakes, exhausts and other excrescences that are not usually seen from the ground.

Mr William Shepherd: Is there any aerodrome at present capable of accommodating the Brabazon?

Mr Lindgren: It is not a question of aerodromes, but of the bearing strength of the runways. If we can so redesign the undercarriage to take the weight, the existing aerodromes will take the aircraft.

The Brabazon came under discussion again in the House of Commons during the Civil Aviation Debate on 1 March 1949. Wing Commander Sir Norman John Hulbert DL (5 June 1903–1 June 1972), Conservative MP for Stockport, noted:

... I was privileged to serve on the Select Committee which inquired into the construction of the Brabazon I. The figures about the Brabazon I are interesting. The total cost of the project at the time when we enquired into it was estimated at about £11 million. Of that £11 million rather more than £5,750,000 was to be expended on the two prototypes and their engines. Only half of that represented manufacturing costs, the other half went on development and research. Over and above that, nearly £5,250,000 has been spent on the Filton runway and the assembly buildings.

The position is that, if the prototype proves successful, B.O.A.C. expect to order not more than three aircraft, and it is quite clear that they will not be able to afford more than £1,250,000 at the outside for each of the aircraft. That means we have a project where the manufacturing costs will run at about £3 million, and £9 million will have been spent on the cost

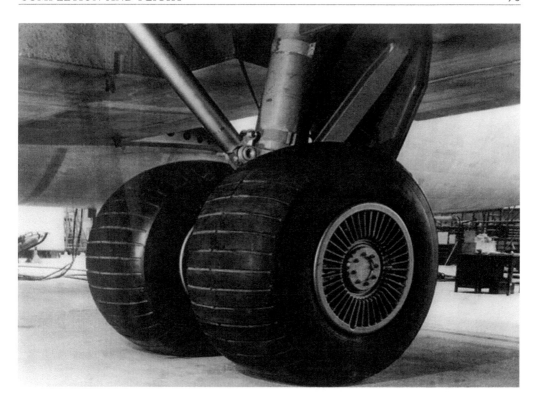

of development and the capital costs that go with it. In short, as far as the large aircraft are concerned, we have reached a stage of development where development costs are quite irrecoverable, and those development costs include substantial capital costs. Those costs obviously are so tremendous that they cannot be loaded on to the sales of the aircraft.

The Brabazon was fitted at one time with the Dunlop 'Compacta' tyre that was of smaller and flatter profile than standard aircraft tyres of the time, with excessive tread width to provide considerable ground contact. (BAC)

We are conducting a national experiment at the country's expense and, of course, in the country's interest. But the State expenditure which is incurred for and on our behalf is very substantial indeed, even when compared with other Government expenditure. The total outlay on the Brabazon project alone is very nearly as much as the total Government expenditure on the North-East Development Area since the war. Bristol has had expended upon it, for good purposes, a capital State expenditure, substantially irrecoverable, of about £9 million. I have no criticism of that. It was very difficult to decide where the expenditure should be incurred.

On balance the Government were quite right in seeing that the capital expenditure and development costs were incurred and that the buildings and runway were erected at Filton. But if this Brabazon experiment is to be successful, as we hope it will, and if, moreover, it is proved that the Brabazon aircraft can be operated economically, then, although the Bristol Aeroplane Company clearly will be able to meet the needs of BOAC, who have indicated that they might require three aircraft, and three only, for their Transatlantic services, – although, so far, BSAAC have indicated that they have no intention of ordering the Brabazon I – I think we can nevertheless assume, that there will be a much bigger overall demand.

But by the very fact of this development itself we have created an unavoidable monopoly to the firm responsible for the development work. No other aircraft constructor in the country could at present construct the Brabazon I. Should it prove successful – we have very good grounds for believing that it will – I am sufficiently confident to believe that it will lead to a demand for large aircraft, which the Bristol Aeroplane Company themselves cannot meet. We are immediately faced with the question of considerable capital expenditure and also expenditure on development costs, because when I say it will succeed, I do not mean that it will succeed necessarily in the form and shape of the present Brabazon I.

The First Flight

Bristol Aeroplane Company themselves described the events surrounding the first flight in a manner so typical of the time:

From its very inception, all who were connected, directly or indirectly, with the Brabazon I had felt it to be a project of high enterprise. Among the workmen actively engaged on the construction of the aircraft, there had throughout been noticeable a very real sense of pride. On the day of the first flight – the day to which their energies had been bent for so long – this feeling found dramatic expression.

The work of final assembly had begun as soon as the Brabazon was safely installed in the new Assembly Hall, and in May, 1948, the extensive programme of pre-flight structural testing had commenced. From January, 1949, onwards, the test programme had been intensified, and a feeling of expectancy began to grow.

The aircraft is towed over the railway line that ran alongside the runway. (BAC)

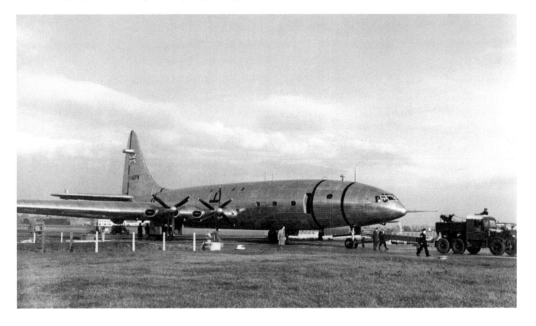

On Friday 2 September 1949, when news went out that taxiing trials were to start next day, Bristol began to fill up with representatives of the press of the world. On Saturday, in bright sunshine, the Brabazon made five taxiing runs up and down the runway, the nosewheel lifting clear of the ground at 75mph before the aircraft returned to the assembly hall for the night. The Pathé News film crew were back at Filton covering the taxi trials. Bob Danvers-Walker described in detail the size of the aircraft and how Bill Pegg spent the entire day taxiing the aircraft up and down the new runway, watched by hundreds of spectators. Bristol's public relations again went to work:

Bill Pegg (the only one not wearing flight overalls) leads Walter Gibb (wearing the sunglasses) and the rest of the Brabazon flight-test crew for a picture at around the time of the first flight. It is supposedly the picture released to the media after the first flight. (BAC)

Sunday, September 4th, broke bright and clear. A great crowd gathered around the airfield boundaries, climbing to points of vantage on farm buildings and pressing against the fences, and at mid-day they saw the Brabazon towed out to the runway. One by one the engines started, and the great aircraft moved off to the west end of the runway.

As she turned, the engine note deepened to a throbbing, vibrant hum. The brakes were released and, with a slight cross-wind blowing, the Brabazon began to taxi faster and faster down the runway again. Over the inter-com, listeners heard the pilot say: 'This may be a take-off ...'

After 400 yards, the nose-wheel rose clear of the ground. There was an almost imperceptible movement of the control surfaces and – suddenly – the watchers realised that the Bristol Brabazon I was airborne. As she climbed, smoothly and majestically, into sunlit skies, a great spontaneous cheer burst from the throats of the hundreds who had seen success crown the high endeavour in which they had shared.

Bill Pegg (towards the bottom of the ladder) and the rest of the flight crew deplane from the aircraft after the first flight. Although foreshortened by a telephone lens, this picture does give a sense of the size of the aircraft. (Simon Peters Collection)

Bob Danvers-Walker of Pathé takes up the story: 'instead there's a quick order over the intercom – "this is it boys" and then Pegg lifts the Brabazon's front wheel after only a four hundred yard run. Another hundred yards and the undercarriage slowly leaves the runway. Airborne!'

Flight somewhat sarcastically reported that the long-awaited maiden flight was '... at least a day before most people expected'. It was the first Bristol Aeroplane Company maiden flight to be watched from the outside by Cyril Uwins, who had become aircraft division managing director after being chief test pilot from 1918.

Bob Danvers-Walker described to cinema-goers how Bill Pegg took the aircraft out over Avonmouth for twenty-five minutes before returning to Filton. For the first uneventful flight, Pegg had nine pairs of eyes to help him watch the 1,100 dials said to be on board. Local legend has it that as the aircraft took off, Bill Pegg is supposed to have uttered the words: 'Good God – it works!'

After the flight, Bill Pegg faced the cameras:

> Well, I've been asked to tell you something about the early trials of the Brabazon. Yesterday, we as a crew handled it for the first time. It moved under its own power, as I say again, for the first time and behaved really very satisfactorily. We got up to speeds in the region of 66 knots and managed to get the nose well off the ground without anything disastrous, or even uncomfortable happening. Now as a result of those trials yesterday, we decided that if all the conditions were suitable we would have a go today. We all woke up this morning and I'm sure the crew will agree with me when I tell you that I looked out of my bedroom window, I'm sure they all did the same thing, to see what the weather was like. The weather was bright, very little wind and in fact everything was extremely hopeful. Well, after the

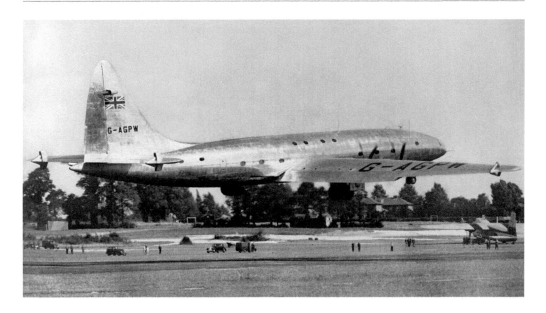

various engine running and pre-flight checks which are necessary with an aeroplane of this size we finally got her onto the runway rather later than we had originally anticipated.

By this time there was a slight cross wind and we had not by then made a decision to take off. However, in taxiing down to the Western end of the runway, the aeroplane in this cross wind behaved so well that we decided, as I said before, to turn round and have a go. There's very little more. We turned round. We headed the thing in an easterly direction and opened the engines up to the take off power, let off the brakes and she was off the ground in some 500 to 600 yards. In fact, she was off so quickly, it took me rather unawares. However, we managed to keep the thing under control and continued to climb steadily up to about 3,000ft.

The approach was made at about 100 knots and we throttled all the engines back at about 50ft. and the landing was entirely normal and completely under control, a very simple business, I was expecting to have perhaps something a little peculiar at this stage but nothing of that sort occurred. We merely pulled the stick back. The aeroplane sat on the ground, I'm told very gently, and we reversed our propellers and the whole thing was again over in about 600 yards. All we had to do then was to taxi it in and face a battery of the sort of things I'm facing now.

It flies! Bill Pegg lifts G-AGPW off from the new runway at Filton for the first time.

For the record, take-off at 210,000lb came after a run of barely 1,500ft at 85mph; the gear was retracted during the twenty-five-minute flight and the landing was judged to be at 88mph, Pegg making gentle use of reverse pitch to slow the machine. A 150-minute flight was made on 7 September and on the following day the huge aircraft put in a welcome appearance at the Society of British Aircraft Constructors display at Farnborough.

Brabazon prototype G-AGPW was just an empty shell apart from flight-test equipment, which everyone expected would be subjected to 'gruelling tests'

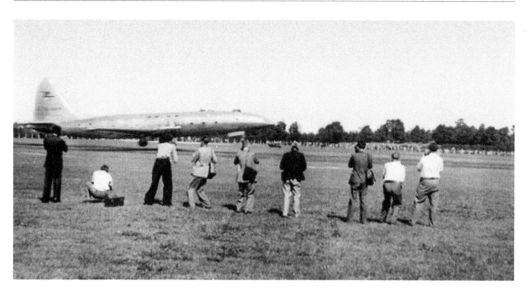

A split second after the main wheels left terra firma for the first time. Photographers line the runway ready to capture the moment.

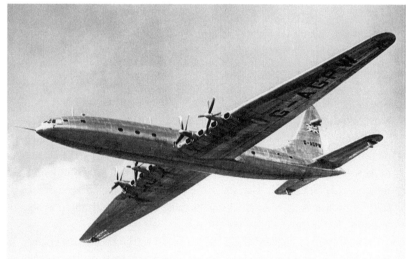

G-AGPW seen here making a flypast during the 1949 SBAC air display.

with the prospect of later undertaking a whole series of 'proving trials on the North Atlantic with at least some interior furnishing'.

Back on the ground, a group of increasingly disgruntled British government accountants in Whitehall watched the flight with a blunted sense of euphoria. For, as well as being vast, the aircraft was proving vastly expensive and the joyous occasion of its first flight was at least two years overdue. Yet when the Brabazon took to the air, the hopes and expectations of an exhausted and war-shattered Britain were lifted with it.

Even before the first Brabazon took to the air this machine was no longer regarded as an 'operational' aircraft as such, being an experimental prototype for an aircraft that some sources have called the 'Brabazon I Mk II'. However, Bristol's own brochure makes the clear distinction that there was simply the Mk I, powered by the Centaurus piston engines, and Mk II, fitted with Proteus propeller-turbines.

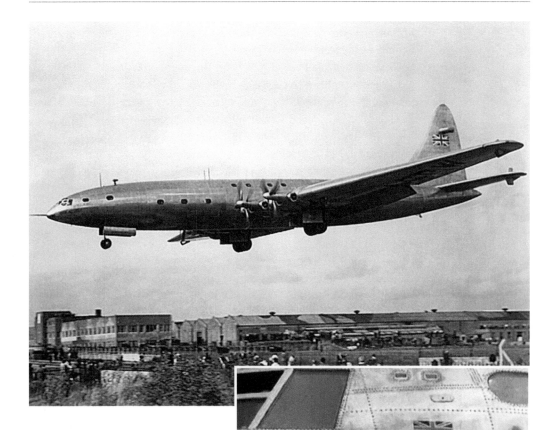

Flight of September 1949 made an effort to rectify some of the most common misconceptions – it's a pity that subsequent authors have never bothered to do in-depth research of their own instead of regurgitating the populist rubbish that went before.

Flight explained that the two marks of Brabazon, though superficially similar, differed considerably in important respects that were not, they believed, widely enough comprehended. They went on to say that:

> The Mk. I, is a research and development aircraft and, as it now flies, a mere shell with accommodation only for the flight crew and test engineers with their equipment. After a period of the most gruelling trials to which any commercial aircraft has been subjected it may conceivably be furnished for transatlantic proving flights; but it is to the Brabazon II that Britain looks for a regular non-stop London–New York service, providing unrivalled comfort with high speed.

The Bristol Aeroplane Company went to great lengths to explain the performance of the Mk II by comparing it to the Mk I, saying:

Supposedly taken at the end of her maiden flight, the Brabazon comes in for a landing with the BAC workshops in the background. Certainly the picture number T.167/981 is in the right sequence range for it to be the actual first landing. At the time the aircraft was carrying the name in small script (inset) not in the large capital letters of later years. (BAC)

Brabazon I was designed on the recommendations of the Brabazon Committee to meet the requirements for an airliner to maintain a non-stop service between London and New York. This route is particularly difficult, as the machine must face persistent winds of high velocity during the crossing to America. To meet this requirement, the aircraft must be able to fly a distance of at least 5,500 statute miles, although the actual stage distance between the two airports is but 3,450 statute miles.

Brabazon I, Mk. 1, fitted with Bristol Centaurus engines, will meet this exacting requirement carrying a payload of 100 passengers, and a crew of 14 persons. The aircraft reaches a maximum performance cruising at 50% engine power of 250 m.p.h. at 25,000 ft. Brabazon I, Mark II, is the developed version fitted with Bristol Proteus Turbo-Propeller engines; it will carry a similar load, but at the increased speed of 350 m.p.h. at 35,000 ft. This is the type of aircraft that could go into service on the North Atlantic route.

One of the flight-test equipment areas, with the flight-test observers in their seats. What is interesting about this view is the sheer size of the interior – the apex of the ceiling must be at least 8ft above the heads of the crew ...

The Bristol Aeroplane Company also went on to explain how a transatlantic passenger scheduled service might work on a weekly basis:

In planning a Brabazon service to New York, two factors of importance merit consideration. The strong head-wind that delays the machine on its westbound crossing speeds its return flight, while the International Time difference reduces the westbound crossing time from the passengers' viewpoint by five hours.

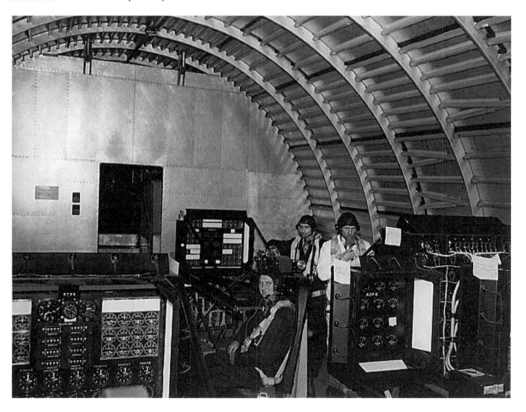

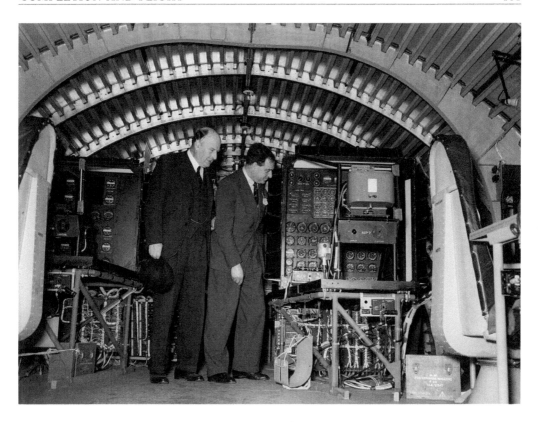

If a steady westerly wind of 70 mph be assumed over the whole route, the following time schedule might be visualized operating one Mark II aircraft cruising at 350 mph:

Sunday Depart London Airport midnight. (GMT)
Monday Arrive New York 0800 hrs. (EST)
 Depart New York 1830 hrs. (EST)
Tuesday Arrive London Airport 0800 hrs. (GMT)
 Depart London Airport midnight. (GMT)
Wednesday Arrive New York 0800 hrs. (EST)
 Depart New York 1830 hrs. (EST)
Thursday Arrive London Airport 0800 hrs. (GMT)
 Depart London Airport midnight. (GMT)
Friday Arrive New York 0800 hrs. (EST)
 Depart New York 1830 hrs. (EST)
Saturday Arrive London Airport 0800 hrs. (GMT)

... which clearly demonstrates a different ceiling line of this picture of Lord Brabazon of Tara aboard the Brabazon, suggesting that this compartment was above the main wing area that crossed the fuselage.

With three aircraft allotted to the route – two operating and one held in reserve – seven services a week in each direction could be maintained.

The degree of comfort provided by Brabazon service merits special attention. It would be possible to leave London after a full evening's engagement, sleep throughout the crossing, and arrive in New York early the next morning, refreshed and ready for any business engagements. A day later

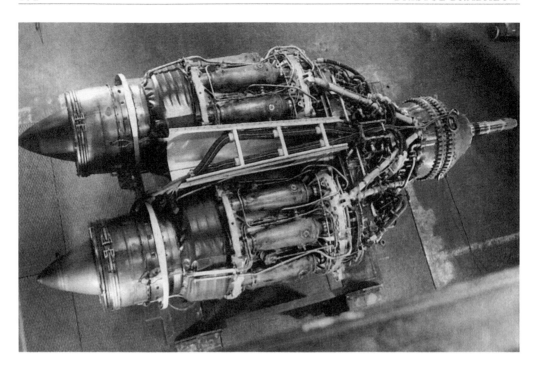

the passenger could be back in London. No intermediate stops with all passengers forced to leave the machine while refuelling takes place. A service giving speed with the utmost comfort – an essential unit in the network of North Atlantic air routes.

Early Test Flights and Crew Training

After all the hype of the first flight, the programme settled down to flight testing and crew training away from the limelight. It was not until early 1950 that Bristol Aeroplane Company released a report on progress.

In the course of the first fourteen flights the Brabazon logged twenty-nine hours' flying. This was during the tests mainly concerned with oil and engine cooling, airscrew strain-gauging and the checking of stability and control. Much additional test equipment required for successive stages of the test programme was installed as necessary.

Cooling of both engines and oil had proved completely satisfactory; in fact, it is considered that the Brabazon's engine installation, with the power units completely encased in the wings, gave better cooling than experienced on any other type of layout. The aircraft's performance promised estimates of cruising and maximum speeds – 250mph and 300mph, respectively – gave every indication of being accurate. A period of flying with one of the four pairs of twin Centaurus power units switched off had virtually no effect on flying or handling characteristics.

Weight, speed and operational altitudes were progressively increased – as was to be expected. By now the aircraft had been flown up to 10,000ft at a weight of

Brabazon and flight crew prepare for her first test flight, Sunday 4 September 1949.

Bill Pegg introduces the flight-test crew to the queen and Princess Margaret in 1949.

98 tons, compared to 94 tons on the early flights. Weight was to be increased to 110 tons and gradually enlarged to the prescribed 130-ton maximum.

The normal flight-test crew numbered ten, although the aircraft had already flown with twenty on board, the additional crewmembers being technicians to handle the test equipment.

Up to this point all flying had been confined to the south-west of England, principally because that area provided the required weather. As the winter weather was expected to recede, flying would take place further afield and Bristol Aeroplane Company were expected to advise provincial newspapers in advance to enable members of the public to be on the look-out for the machine.

Some sections of the press had started to speculate that the Brabazon would shortly undertake her first transatlantic flight – the Bristol Company described these rumours as 'purely conjecture and emphasises that a test of this kind plays no part in the immediate development programme'. The official statement from the company stressed that, while such a flight might ultimately take place, it could only be approached after further extensive testing.

At the same time, a complete reserve crew for the aircraft was being trained. Co-pilot Walter Gibb had made a number of take-offs and landings under the supervision of Bill Pegg, with E.H. Statham stepping up as a 'new' second pilot. To ensure continuity of testing, all the remaining members of the flight-test crew soon received 'understudies'.

The somewhat sparse Brabazon flight deck, with Bill Pegg in the left-hand seat. (BAC)

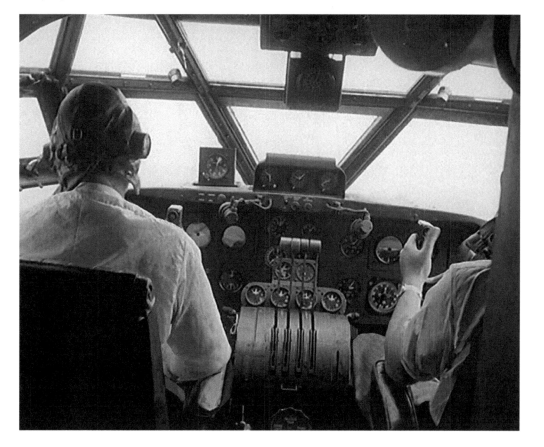

The Brabazon I Mk II

Manufacture of the sole Mk II (constructor's number 12780, civil registration G-AIML and unused military serial VX343) took place quickly during 1949. Some odd names appeared in the contractor list, including Auster Aircraft as supplier of the complete vertical tail! By the end of 1951 the Mk II was in final assembly in the now completed Brabazon Hall. The Mk I, however, persistently grew fatigue cracks, especially around the propeller anchorages, and so never received an unrestricted Certificate of Airworthiness and thus never wore British European Airways markings. Had these cracks not manifested it is quite possible that the Brabazon might have spent years in profitable use, though not even Peter Masefield's wish to salvage something could have made the programme a success.

Despite extensive searches through all the records, it has proved impossible to find a piece of paper stating the decision to regard the Mk II as the only production aircraft; it was merely assumed and eventually taken for granted. Indeed, it is no easy matter even to discover what the programme was. In *Jane's* for 1945–46 no indication is given as to how many aircraft were involved, and though precise weights and performance figures were given, the choice of piston or turbine was completely sidestepped and the propulsion is merely said to be by 'eight Bristol engines'. In the 1950–51 volume, however, it is clearly stated 'an official order for four of the type has been given, the first being powered by piston engines and the others by gas-turbines driving airscrews'.

There never was an 'official order' for more than a single Mk II, to 'Specification 2/46'. *The Book of Bristol Aircraft* gives the power of the Mk II as being 'four pairs of Bristol Proteus turbine-airscrew units', though that book was published as early as November 1946. At that time the Proteus had not even run, and Frank Owner was busy planning it as a reverse-flow engine with the air intake near the back and an axial compressor arranged back-to-front.

The Brabazon cruising in level flight – the fuselage bands were to aid photographic recording. (BAC)

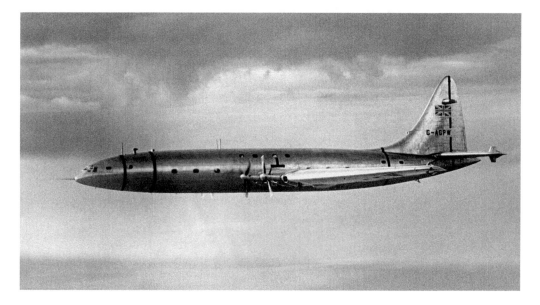

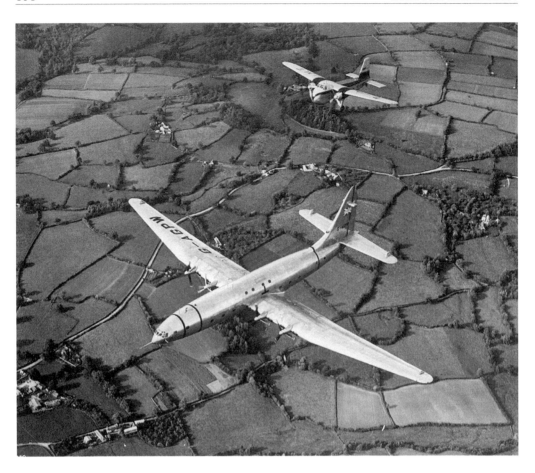

This was because burying it in the wing of the Brabazon I Mk II, or for that matter a Saro Princess, called for an engine that was short but fat, with leading edge inlets and ducts feeding the air to plenum chambers around the engines. Eventually, it was decided to arrange the engine power sections parallel, unlike the skewed arrangement of the Mk I, with each pair driving through a common gearbox to both units of the Rotol contraprop. This made the whole installation a single package, and the coupled Proteus was regarded as a single engine with two power sections, like the German DB.606 and 610 of the He.177.

Use of this engine took about 10,000lb off the empty weight of the aircraft and considerably raised cruising speed and altitude. On the other hand, the wing stayed at its daunting t/c ratio of 21 per cent, which was about twice what was needed. The Bristol Company studied the possibility of making the outer wings as integral tanks, before deciding not to.

There were, however, some profound changes introduced with the Mk II, which could well have been on the Mk I. One was to reject the odd nose in favour of a conventional front end with stepped windscreen panels. Another was to change the engine installation to the extent of dualling the jet pipes and cooling airflow through the wing box to pass above the flaps. The main gears were changed to Dowty four-wheel bogies, with much lower footprint pressure and bending moment on airfields. This was due to BOAC influence, as was the

remarkable decision to use manual flying controls with spring-tab operation, plus partial hydraulic boost at high IAS only. A further, most interesting decision was to keep down wing weight by fitting a gust alleviator.

Research during and just after the war revealed the unwelcome existence of sharp-edged gusts in the atmosphere at heights above 35,000ft. Flying at 330mph, the huge Brabazon would thus suffer violent wing and body loads and it was eventually decided – mainly by the RAE – to devise a system with a detector on the tip of the nose pitot boom that sensed airflow incidence and, on encountering a sudden change, triggered the alleviation system. This would then very rapidly deflect both ailerons up or down together to cancel out the changed lift on the wing. This seemed to be a way of giving the body a smoother ride without necessarily reducing wing bending loads, but it was meant to do both jobs and, without it, the wing would have had to be much heavier. The system was put into an RAE Lancaster but not tested. Someone, it was alleged, delivered the Lancaster to Bristol and, on the way, switched on the gust alleviator. He reported to Bill Pegg the system really did work very well; with it on, the ride was much smoother. It was a little later that they discovered it was connected the wrong way round: the alleviation had actually intensified each gust!

The Bristol Type 167 Mk I & II. A line drawing from the Bristol Company's brochure, showing the Brabazon Mk I in white, with the differences created with the Brabazon Mk II shown with the black lines.

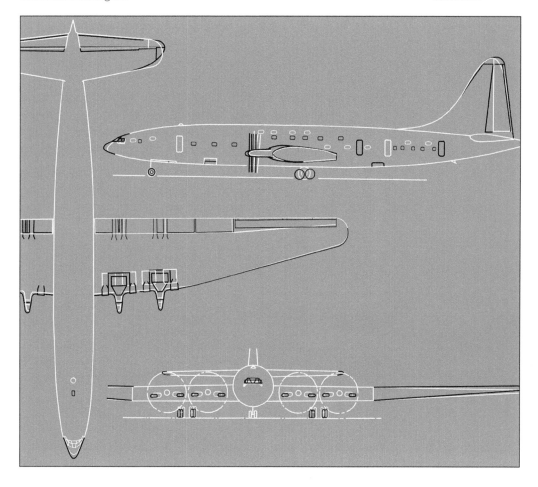

Publicity and Public Appearances

Now that the aircraft had flown, it was time to present it to the public – and present it both the government and company did.

A major item was the visit to Heathrow, then termed 'London Airport'. In June 1950 the Mk I received a special category 'C of A'. It was furnished with thirty seats in the rear fuselage and many guests were deeply impressed by the smooth ride and extreme quietness during flights from Heathrow on 15 and 16 June, and later at Filton and Farnborough. Peter Masefield of BEA even suggested they might use the monster with 180 seats on peak services to Nice. Masefield had earlier described the Brabazon as not only 'The only type capable of regularly making direct flights between London and New York non-stop whilst still showing a profit', but also as 'the most economical aircraft for stage lengths from 2,350 to 3,920 miles'. As chief executive of BEA he was unique among Britons in having the authority and the guts actually to use the aircraft. BOAC merely kept emphasising their 'willingness to operate it when the time comes', whilst secretly praying that such a time never would come.

Bristol Aeroplane Company themselves described the visit to London Airport in the effusively glowing prose of the day. 'This is an historic occasion, not only in Britain but in the entire world,' said Lord Pakenham, the Minister of Civil Aviation, of the Brabazon Type I's visit to London Airport on 15 and 16 June 1950.

When the great aircraft came in to land on the 3,000yd main runway on 15 June – her first landing on any airfield other than Filton – work stopped in the hangars as hundreds of workmen streamed out to get their first glimpse of the Brabazon. All that day, the public queued for places in coaches that slowly circled the aircraft. With the arrival at 11.30 a.m. the following day of Lord Pakenham and the Minister of Supply, the Rt Hon. G.R. Strauss MP, the official ceremony began.

The Brabazon is towed back to the parking area after another flight. Of interest is the lower engine bay doors that are open – it was thought this would help cool-down after flight – and of course the railway running across the airfield! (BAC)

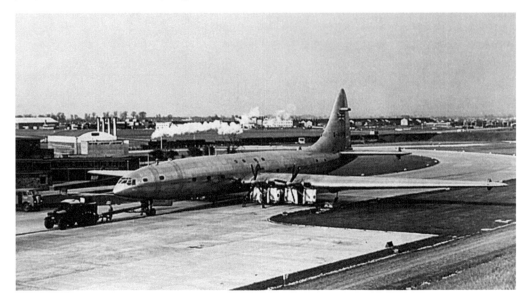

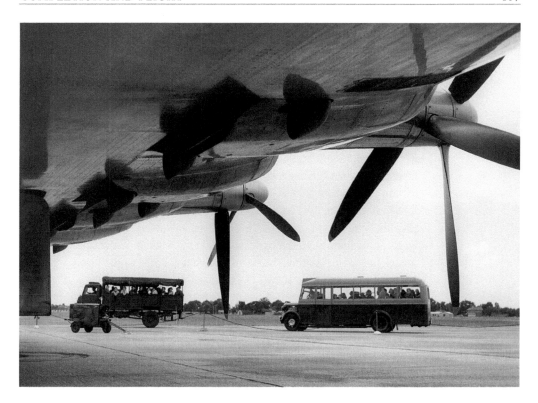

The Brabazon made two demonstration flights, astonishing spectators with the shortness of her landing and take-off runs, and the ease with which she manoeuvred on the ground. As she flew low over the airport, dwarfing all other aircraft, Mr Strauss summed up the feelings of many present: 'She looks more beautiful in the air,' he said, 'than any 'plane I have ever seen'. However, the visit to Heathrow was more than a prestige flight; it was the first opportunity to make landing and take-off tests on a first-class civil airport and to observe taxiing performance on standard 50yd taxiways, which were far narrower than anything in use at Filton. Said Mr A.J. Pegg, the company's chief test pilot, later: 'We can now treat the Brabazon just like any other air-liner. In fact, it is even more versatile than some of the smaller four-engined air-liners in actual operation today.'

The underside of the massive wing was not often photographed, but here the engine exhausts and cooling air outlets are clearly visible. (BAC)

The flight to London Airport marked, in effect, the end of the first phase of flight testing and an important change in the character of the test flights. Hitherto, the Brabazon Type I's flying had been largely confined to a comparatively small area of southern England; now she would be ranging farther afield. More important still was the fact that success of the airport tests had provided final and convincing proof of the practical potential of really large airliners. It brought appreciably nearer the day when the Bristol Brabazon Type I Mk II would go into service on BOAC transatlantic routes as Britain's first 'Queen of the Air'.

Details started to surface as to the aircraft's interior. Working with BOAC three main cabins of thirty-six, thirty-two and thirty-two passengers were arranged. The final colours matched the corporation fleet's, these being

principally blue, grey, maroon, beige and buff. The rear cabin would be equipped with a cinema projector and radio for passenger entertainment and a flight progress chart would indicate the aircraft's position throughout the whole Atlantic crossing. A thirty-two-seat dining cabin, with a lounge bar, galley and server, would be accommodated over the wing centre section at a half-deck higher level.

BOAC went to the length of explaining that green was a colour that would not be used, for although '... it is restful to the eyes, it has certain disadvantages among which is the fact that it is both a mourning and a sacred colour in certain eastern countries'.

Then it was on to the Farnborough Air Show. For flights made at the SBAC display the Bristol Brabazon Type I was insured for some £750,000 – estimated to be half its actual value. The risk continued only while the Brabazon was warming up, in flight or landing, the aircraft being uninsured when the engines were not running. During the show Bill Pegg's instructions to the crew were relayed to the ground. It was recorded by the press that the aircraft's speed during the display was deceptively slow (this was a phenomenon that many witnessed in later years with the massive size and bulk of Boeing 747 and Airbus A380), as the size of the aircraft made it appear to be moving slower.

In August the Brabazon was taken over the Irish Sea to Belfast to appear at the RAFA display at Sydenham airfield. On board were pilots Walter Gibb and Ronnie Ellison and a group of Air Training Corps cadets. It was the first time that the aircraft had carried passengers other than government officials, technicians or pressmen. Later that month it visited Prestwick in Scotland. The

As part of the 1951 Festival of Britain a large-scale cutaway model of the Brabazon Mk II was displayed to the public in a travelling exhibition.

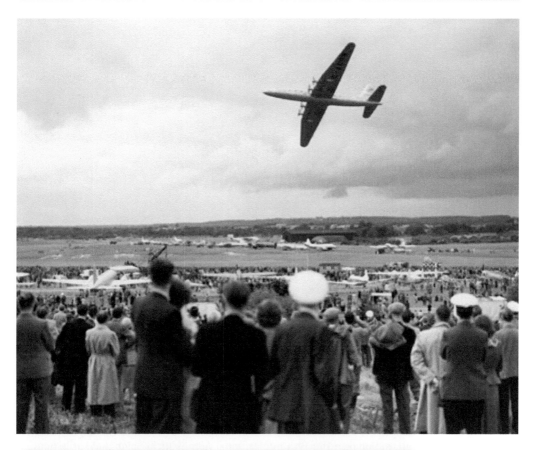

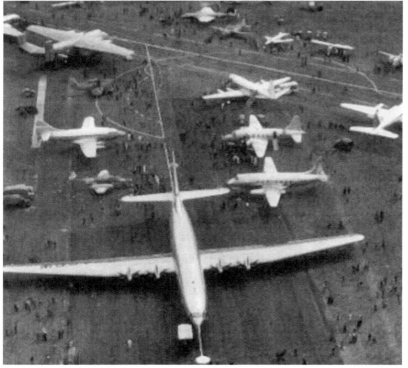

Two pictures showing the appearance of the Brabazon at the Society of British Aircraft Constructors display at Farnborough.

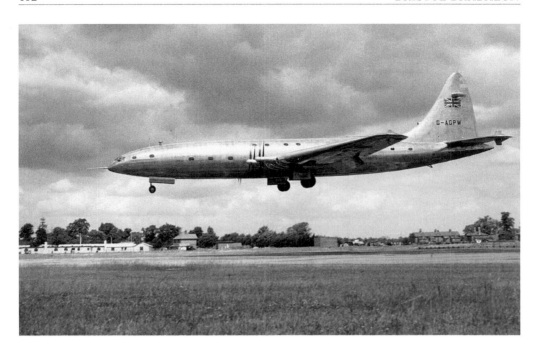

The slight nose-down
attitude of the
Brabazon was
characteristic of any
landing. (BAC)

aircraft was also to star in a BBC television broadcast called *Aircraft of Britain'*, during which viewers saw Sir Miles Thomas from BOAC, BBC commentator Frank Gillard and Cyril F. Unwins from Bristol Aeroplane Company discuss future plans from the lounge of the Brabazon.

On 1 July 1951 there was a closing ceremony of the Grande Fête Aérienne Internationale – the 19th International Aeronautical Salon, held at le Bourget airport, just outside Paris. It was the one and only time the Brabazon Type I left British shores.

That afternoon, Bill Pegg took the MK I over the Channel, while on the ground at Le Bourget Captain 'Bristol' Bartlett prepared to give a commentary in English. After numerous radio calls broadcast over the *système de sonorisation* (the public address system) to 'George Peter Willie', which went unanswered, followed by a few hopeful sounding 'Hullo Bills', contact was eventually made. Pegg gave his position as 5 miles north of the airport, so all heads turned in that direction to search the distant haze. Pegg took the aircraft for several low runs over the airport, much to the amazement of the gathered multitude.

After around 300 hours of flight testing, the aircraft returned to London Airport in early August 1951. By now there were subtle differences in the appearance of Mk I G-AGPW. Gone was the extended probe on the nose that carried a pitot head forward into the undisturbed air ahead of the aircraft. In its place, a normal pitot head measured airspeed and its location was taken by a Decca navigator.

Development of the gust-alleviation equipment was also proceeding well. Response measurements had been made in flight with the detector vane, while the rest of the mechanism was undergoing bench testing. The detector vane itself, of aerofoil section, could be seen protruding from the nose of the fuselage near the captain's station. It registered the effect of gusts a fraction

of a second before they reached the mainplane, and the reaction was translated to the ailerons. The position of these would then automatically be altered to counteract the effect of the gust, so lessening the strain on the mainplane when flying in rough weather.

A close-up of the huge and unnecessary mass-balances fitted to the empennage. They were later removed. (BAC)

The 'lumps and bumps' caused by the external mass-balances on the rudder and elevators had disappeared – evidence that the testing work done on the controls had proved they were not needed. As a result, the reduction of drag was considerable and the pilots reported that control 'feel' was greatly improved. As an example of the savings the removal of this equipment made, the Bristol Company likened it to that of three extra passengers.

As one correspondent recorded of a demonstration flight:

Even if one has inspected the Brabazon at close quarters before, its great size still comes as a surprise. This is particularly true of the interior; the main saloon being reminiscent of one of the larger-type Nissen huts used as mess rooms on RAF dispersal stations.

As the eight paired-Centaurus start up, one by one, a distant rumble, some vibration and a high-pitched drone can be detected. Taxiing on runways is unusually smooth, and on take-off it was not possible to tell when the wheels left the ground. The engines have a throaty roar at take-off power, and the noise level is comparable with that heard in current airliners such as the Stratocruiser. When climbing and cruising the sound is more subdued and rumbling.

It is most impressive to walk forward along the length of the fuselage; to look out of the windows in each compartment and to see the wings get nearer, then to look down their vast gently-flexing span, to stand abreast the co-axial airscrews, and finally to see them recede until they appear to belong to another machine in formation behind.

One notices the comparatively large aileron deflection used to control the aircraft and, during take-off and landing, the rather unusual movement of the three huge flap sections on each mainplane. These appear to be capable of moving independently and in the fully lowered position present a truly formidable braking surface.

On its passenger demonstration-flight Brabazon I was taken on a circuit of London at about 175 kt indicated airspeed and 2,075 r.p.m. for the Centaurus engines. The ride was smooth but, frankly, very little different from that experienced in any other large aircraft. Few passengers realised, probably, that the occasional slight shudder was the Brabazon's way of reacting to rough air. The conditions were distinctly bumpy at times, although there was little to indicate this in the aircraft's stately progress.

A wide circuit and very long approach was made on return to Heathrow, and once the wheels had slowly moved down, the speed was kept at around 130 kt. Touch-down speed at the medium weight was 100 kt with the tail far enough down for the attitude to be visible to passengers. The wheels touched so gently that it was almost impossible to tell the moment of contact without looking out of the window, and the run was shortened with the aid of the braking airscrews.

The amount of head room available – even after the fitment of all the interior trim – was truly breath-taking. If the mock-up is to be believed, the Brabazon would have had overhead storage bins, pre-dating this feature by a considerable number of years. (BAC)

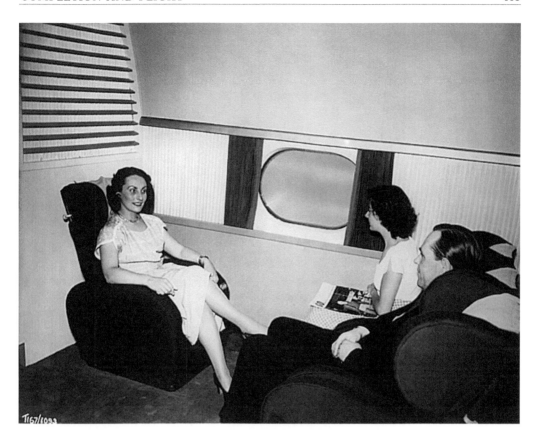

TI67/1033

At the controls, Mr. 'Bill' Pegg commented that the only one truly manually-operated among all those surrounding his captain's station was that used to adjust his seat. The majority of engine instruments and controls are to be at the engineers' stations, the cockpit being neat, orthodox and relatively simple.

Part of the interior mock-up of the Brabazon Mk II transatlantic machine; the panel above the window is a fold-down bed. (BAC)

By the time the 1951 SBAC Farnborough Show arrived – and it was an annual event back then – the aircraft was not flown in the display, but parked so that visitors could inspect the interior.

The Brabazon Type I – or at least the concept and with a slightly modified name – made a somewhat surreal appearance in the first series of the cult BBC radio series *Crazy People* in 1951, a programme that was to be later re-christened *The Goon Show*. In this early episode Professor Osric Pureheart, a somewhat eccentric scientist played by Michael Bentine, designed and built the giant Brabagoon airliner. The launching of his magnificent machine was accompanied by powerful surging engine noises with a puzzled Pureheart unable to take off until his voice was heard shouting above the noise 'Madame, will you please tell your small boy to let go of the tail!'

Unfortunately, just like the real thing, this episode of *The Goon Show* failed to survive, but its existence appears to be the first recorded account of the aircraft being both parodied and maligned – it was to be the first in a long list of such events.

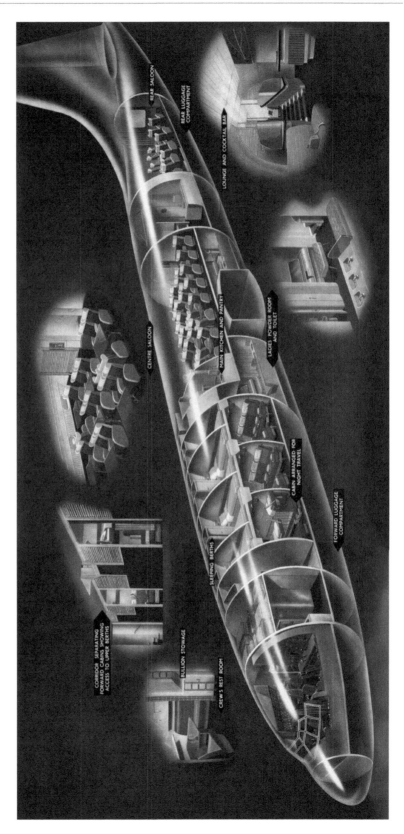

Truly stunning artwork from the Brabazon brochure, showing the interior layout of the Brabazon Mk II. (BAC)

Disillusionment

On 29 January 1951 the subject of the Brabazon was raised in Parliament, when the following exchange took place:

> *Air Commodore Harvey*: asked the Minister of Supply if he will make a statement on the Brabazon project, and on his intentions regarding the completion of the construction of the second aircraft of this type.
>
> *The Rt Hon. George R. Strauss, Minister of Supply*: The Brabazon project is proceeding satisfactorily, and the second aircraft will be completed.
>
> *Air Commodore Harvey*: Is the Right Hon. Gentleman satisfied that the completion of this project will not in any way impede orders placed for military equipment with the Bristol Company? Further, while recognising the value of research on the project, may I ask if he does not think it is time to finish with it and spend the money in other directions?
>
> *Mr Strauss*: The answer to the first part of the question is, 'Yes, Sir'. I am quite satisfied that it will not interfere with the military demands on this firm. I am also satisfied that the completion of this experiment – that is, the building of the second Brabazon, without which the building of the first would have been almost useless – is very well worth while.
>
> *Sir Herbert Williams MP, Croydon East*: Can the Right Hon. Gentleman say what these planes will be used for when the other is finished?
>
> *Mr Strauss*: They may be used for many functions but if they were not used at all the scientific knowledge which has been gained by the building of these planes has already been invaluable, and will be more invaluable when experiments are finished.
>
> *Colonel Ropner*: Is it not a fact that a number of American aeroplanes at least as large as the Brabazon have flown over to this country quite recently, and is not the scientific knowledge available to the Americans also available to the Right Hon. Gentleman?
>
> *Mr Strauss*: No, Sir, a great deal of new knowledge, which will be quite original, will be gained, particularly after the second Brabazon has been completed and flown.

A few days later, on 31 January 1951, this somewhat waspish exchange took place, when MP Mr G. Williams asked the Parliamentary Secretary to the Ministry of Civil Aviation why the Brabazon was not to be used as a commercial airliner:

> *Mr Beswick*: The Brabazon project was undertaken for experimental purposes, and with a view to possible use on trans-Atlantic services. As the result of a review of recent developments, it now appears that the commercial requirements for this and other long distance routes can be met more economically by other British aircraft which will be available in the future.
>
> *Mr Williams*: Does this mean that this aircraft will never earn a penny? If so, is it the intention of the Government to write off this sum at once or over a number of years?

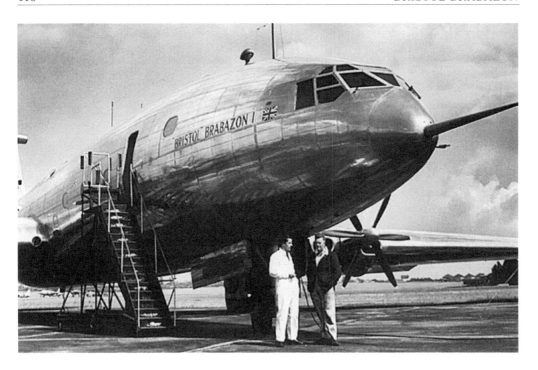

*Resting between
flights. The slightly
strange shape of the
nose, going back
to the area behind
the flight deck, is
noticeable in this
picture. (BAC)*

Mr Beswick: The meaning of the answer is what it says.

Air Commodore Harvey: Is it not a fact that the Government knew this at least twelve months ago? Are they not aware that they are merely repeating another nuts scheme, and that the best thing to do is to cut it right out?

Mr Beswick: No, it is not a fact that the Government knew it twelve months ago. There are a number of factors, including the development of new aircraft, about which we could not be certain twelve months ago.

Mr Awbery: Is my Hon. Friend aware that the experience gained by those building the two Brabazon aircraft was worth the money we spent upon them?

Major Guy Lloyd: Could they not be used for carrying groundnuts back from Africa?

The comment about groundnuts refers to the Tanganyika Groundnut Scheme, which was a plan to cultivate tracts of what is now Tanzania with peanuts. A project of the British Labour government of Clement Attlee, it was abandoned in 1951 at considerable cost to the taxpayers when it did not become profitable. Groundnuts require at least 20in of rainfall per year; the area chosen was subject to extreme periods of drought.

In February 1952 the government stopped work on the Mk II '... temporarily, in view of the poor economic state of the country'. The Conservative Minister of Supply, Edwin Duncan Sandys (who had succeeded George Strauss on 31 October 1951 and was later the man who probably did more to single-handedly destroy the British aviation industry than anyone before or since with his policies), was quoted as saying he had 'reaffirmed faith in large aircraft' and that work would go on again 'when conditions became more favourable'.

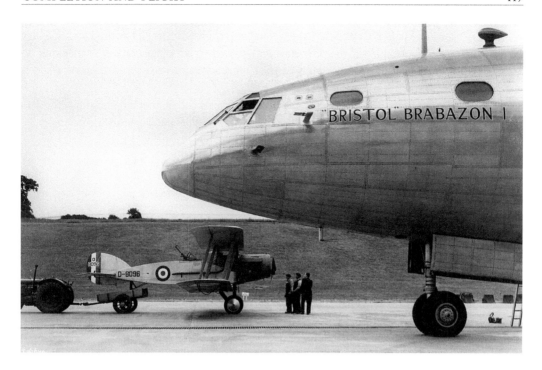

On 22 April 1952 the subject of the Brabazon came up in the House of Lords:

Viscount Swinton: My Lords, the first Brabazon aircraft, which has piston engines, was built for experimental use. The aircraft is now in the course of its development flying and it is intended that that work should proceed. As regards the second Brabazon aircraft, it was earlier intended that it should be fitted in the first instance with Bristol Proteus II propeller-turbine engines. However, it has become evident that great economy would be achieved by waiting for the production of the more powerful Proteus III engines which are not yet available. It has, therefore, been decided to postpone for the time being the work of completing the second Brabazon.

Lord Ogmore: My Lords, with regard to the first Brabazon, as this machine is completed and her trials must now be concluded, may I ask the Government whether they will put her on the London–Paris route this summer, as she would be a great attraction to travellers?

Viscount Swinton: My Lords, I should not like to give an answer to that question offhand. In order to prepare the Brabazon for civil transport, a great deal of work and expenditure would have to be incurred. Whether that would be a practical proposition – by which I mean an economic proposition – would be a matter for consideration between the BEA, who presumably would charter her, and the Ministry of Supply. If the cost were out of proportion to the revenue which would be received, while it might ultimately be attractive to travellers it might not be equally attractive to the British taxpayer.

Lord Ogmore: My Lords, it might be as attractive as to keep her doing nothing. In any case, I understand that BEA are anxious to use her and that she is in fact almost ready for use, apart from the seating. If the seating were put

Bristol products bridging the years. The Bristol Fighter D9096, restored by Bristol Aeroplane Company, is parked by the nose of the Brabazon. The fighter is now with the Shuttleworth Collection, as was the nameplate of the airliner for many years. (BAC)

*Two images of the
Brabazon's visit to
London Heathrow –
note now the lack of
mass-balances on the
tail surfaces.*

in to the standards which would be required, she could be used very soon.
I would ask the Government to make up their minds one way or the other,
because the aircraft would be a great attraction and a great revenue-earner
on this route.

Viscount Swinton: My Lords, I am perfectly certain that the Government will
make up their minds as soon as they have a definite proposition put to them.

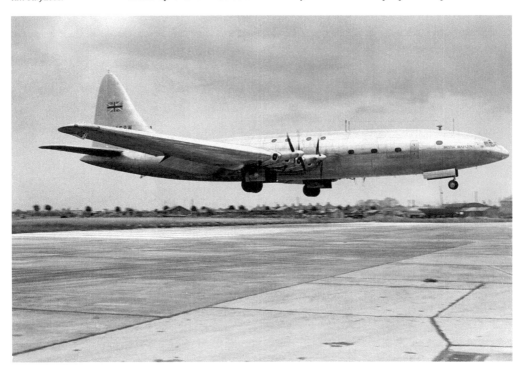

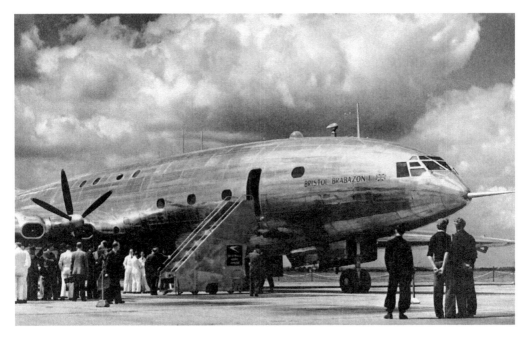

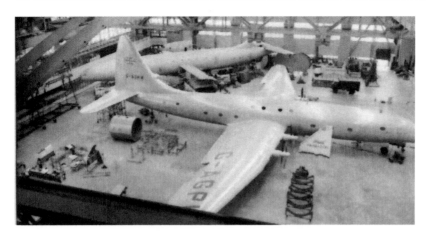

Not the best of images, but one that shows the two machines in the assembly hangar at Filton.

'PW' outside the assembly building.

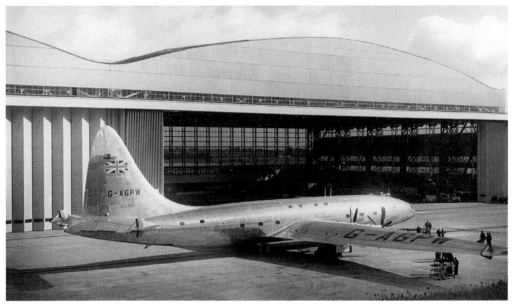

I answer only as I am informed, and I did ask about this matter. It is by no means certain that BEA, looking at it as a commercial proposition, would wish to make the necessary overtures to the Ministry of Supply. I understand that putting in the seating is not just like putting a garden chair or two on the lawn on a fine day. It would be a pretty extensive and expensive operation.

The Axe Falls

The formal abandonment of the whole project was announcement by Sandys in the House of Commons on 17 July 1952 – although no trace has so far been found of it in *Hansard*, the edited verbatim report of proceedings of both the House of Commons and the House of Lords. The Mk I last flew on 20 September 1952, logging a mere 382 hours 15 minutes. It is reported elsewhere that Sandys said he was:

satisfied that all possible technical information has been received from it. That neither civil airlines nor fighting services could foresee any economic use for the Brabazon 1 or the uncompleted 2. I have accordingly given instructions that it should be dismantled. Any components and equipment of use for experimental or educational purposes would, of course, be preserved.

In October 1953 both Brabazons were cut up at Filton by aircraft scrappers R.J. Coley of Hounslow. The value of the material salvaged from the two aircraft and their jigs was put at 'about £10,000'. This did not include the nose gear – which gives little idea of the size of the aircraft but survives in the Science Museum.

The original programme estimate from 1943 was £4 million. The 1944 estimate for a programme of twelve Mk I aircraft was £8 million. On 31 March 1951, the contract price for one Mk I and one Mk II was fixed at £4,157,506, excluding engines. This was only a little up on the 1944 estimate for two Mk Is, but the assembly building and the huge runway overran costs by more than double to raise the programme total to about £14 million. In 1953 Sandys said the 'total spent or committed' was about £6.5 million, but he left out the building and runway.

So much for Britain's 'Number One priority in post-war aviation'; it seems that British politicians have always found aviation difficult to understand. During the lifetime of the Brabazon there were hardly any British aviation professionals – not even the two BOAC men who sat on the Brabazon Committee. In 1956 Lord Brabazon made the comment that the committee had never been asked to say whether the aircraft should be built '... but the Minister of Aircraft Production decided to have it built, without asking who wanted it, or who was prepared to use it ... a somewhat strange piece of forward planning'.

A sad end: the two airframes are unceremoniously destroyed in the assembly building at Filton by R.J. Coley, the aircraft scrappers.

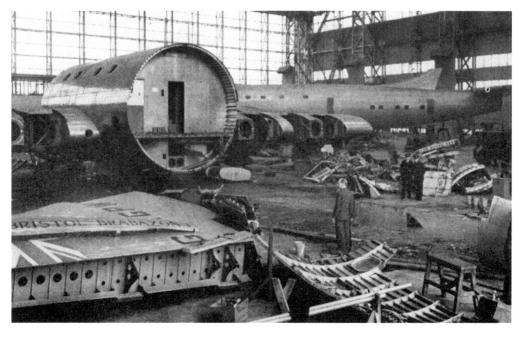

It is not exactly clear which minister Lord Brabazon was referring to – John Llewellin was replaced as minister on 22 November 1942 by Sir Stafford Cripps who held the post as the head of MAP until 25 May 1945, when he was replaced by Ernest Brown. The MAP then became fully merged into the Ministry of Supply on 1 April 1946.

It is not hard to sympathise with 'Brab', who it seems had come to wish his name was not forever associated with what was regarded by the popular press as a stupid white elephant. However, sometimes a major long-term development may have to be funded by governments in the belief that customers will later emerge. In 1943 there was no reason to doubt that customers would emerge for the Bristol Type 167; at the time the idea was not inherently doomed to fail. What defeated it was lack of industrial strength, which made it take too long, and the predictably pathetic, almost cowardly attitude of BOAC, which took away any urgency from the programme and failed to provide the link needed with a customer.

Like the Saunders-Roe Princess flying boat, the Brabazon concept was a fusion of pre- and post-war thinking, using then highly advanced design and engineering. For many years it was thought that even though the design and engineering was right, to build an aircraft that was too spacious, too luxurious and too slow was just not required in the post-war world.

Certainly in 2011 the Brabazon specification may sound excessively opulent and wasteful, until one considers that all the airlines of today are aggressively marketing flat-bed seating for business and first-class passengers. Indeed, British Airways, the successor to BOAC, are operating a very successful Airbus service across the Atlantic from 'London City' Airport into New York's John F. Kennedy Airport. When BA first launched this business-class-only service at the height of the recession using thirty-two-seat A318 aircraft that in standard configuration normally carried 107 passengers, critics said it would be a failure. Nevertheless, it was not long before BA CEO Willie Walsh was saying that the London–New York route had been 'even better than we'd expected'. He added, 'It's a word of mouth success. London City is a convenient airport for business, and we can put more flights on at peak times.'

Such is the importance of this particular service, BA designated the outbound and return flights with the BA001 and BA002 code, which were previously used for its transatlantic Concorde services – another aircraft type that Bristol had an important hand in.

Perhaps the Brabazon was just ahead of its time!

INDEX